ISLE OF SHEPPEY
THROUGH TIME
John Clancy

AMBERLEY PUBLISHING

Hasted's map of the Isle of Sheppey, 1797, extracted from his book *The History of Kent*.

First published 2011

Amberley Publishing
The Hill, Stroud
Gloucestershire, GL5 4EP

www.amberley-books.com

Copyright © John Clancy, 2011

The right of John Clancy to be identified as the
Author of this work has been asserted in accordance
with the Copyrights, Designs and Patents Act 1988.

ISBN 978 1 4456 0647 7

British Library Cataloguing in Publication Data.
A catalogue record for this book is available from
the British Library.

Typeset in 9.5pt on 12pt Celeste.
Typesetting by Amberley Publishing.
Printed in the UK.

Introduction

The Isle of Sheppey lies off the north Kent coast at the mouth of the River Medway in the Thames Estuary, and this is what has given the island such strategic importance since Roman times. The Isle of Sheppey consists of the towns and villages of Queenborough, Sheerness, Minster, Eastchurch, Leysdown and the deserted hamlets of Elmley and Harty, each of which, incidentally, once comprised the three separate islands of Sheppey.

Sheppey is separated from the mainland by a deep channel known as the Swale, which is not a river as many believe, as it is tidal at both ends, it being an arm of the sea. The island is connected to the mainland by a bridge at Kingsferry, and before this, access to and from the island was by means of a ferry boat – one of three situated at Kingsferry, Elmley and Harty. The islanders have long been dependant upon this link with the mainland; without it they are isolated from the rest of Kent.

The island is nine miles long by four miles wide and has around 22,400 acres of land. The southern half of the island bordering on the Swale is largely marshland, constantly being built up through silting action. If it were not for dredgers keeping the channel open for shipping going to Ridham Dock, Sheppey would have become joined to mainland Kent long ago, as happened with the neighbouring Isles of Thanet and Grain. In direct contrast, the northern coastline rises to almost 250 feet at Minster, where the cliffs have been eroded for centuries and continue to do so, making them a rich hunting ground for keen geologists and fossil hunters. Here, many hundreds of acres of prime agricultural land and history have been lost to the sea.

Each of Sheppey's towns and villages is steeped in history and heritage, despite much of the island now being occupied by caravan parks on its former agricultural land. The island has long held a close association with the beginnings of aviation in this country. The Short brothers

established their first aircraft factory at Leysdown, and at Eastchurch the Royal Aero Club trained the first four navy pilots as well as awarding Winston Churchill and Lord Brabazon – amongst others – their pilot's licences. The field where aviation was conceived is now a prison. The once all-important dockyard is now little more than an industrial estate and the riotous dockside area, Blue Town, is now just a quiet backwater. Queenborough grew from a tiny fishing hamlet to become the island's principal port, and in around 1339 Edward III built an impressive castle there as a part of his national defences; he named the town in honour of his queen, Philippa. The castle was demolished in 1650 on Oliver Cromwell's orders and today no traces of it remain.

The area connecting Blue Town to Queenborough was itself once a thriving community known as West Minster, but that too has gone. It stood in the area of the gasometers, sandwiched between the sea wall and the railway line, and comprised of two blocks of back-to-back houses, two public houses, a post office, a general store and a small gospel hall; its population was around 200. West Minster was obliterated from the map after the disastrous east coast floods of February 1953 and today the wasteland is used as a lorry park. The abbey at Minster, once the epicentre and jewel of the island, a 'must-see' site for medieval pilgrims, is now just a ruin.

The Isle of Sheppey has long been and still is a favourite destination for holidaymakers and day-trippers, and is a fascinating place to explore with much awaiting discovery.

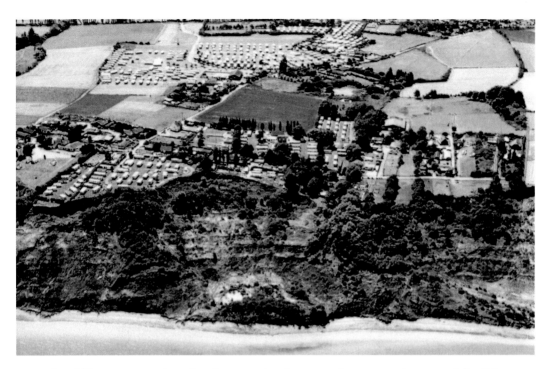

The cliffs at Minster; their fragile nature has become a boon to geologists and fossil hunters. Beyond it can be seen former agricultural land, now being used as caravan parks.

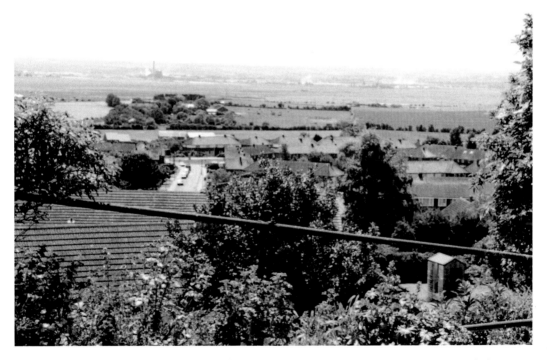

Looking southwards towards the Swale from Minster, a vista of bleak marshland with few signs of habitation can be seen.

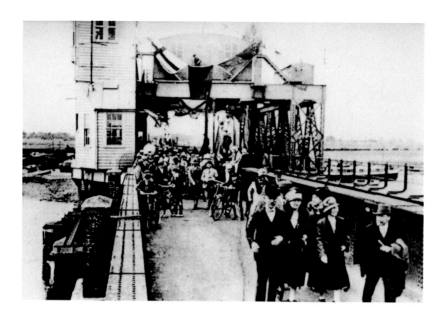

Bridging the Gap

Today, bridge number four links Sheppey to mainland Kent. The first was built by the London, Chatham & Dover Railway Company to an Admiralty design known as a bascule bridge, and opened to rail traffic on 19 July 1860. To begin with, a toll fee was charged for crossing this and bridge number two, but this was abolished on 2 July 1929 when the Kent County Council purchased the rights from the railway company and abolished all toll fees. To celebrate this, local people congregated and walked back and forth across the bridge, as can be seen here. The next bridge was of a rolling lift design known as a Scherzer-type bascule bridge, lifting like a castle drawbridge, which allowed for road transport as well as the railway. By 1959, it was time for bridge number three, built to a design of four towers and a lifting central section, but a gradual increase in traffic flows to and from the island brought increasingly serious vehicle hold-ups, so by 2004 it was agreed that a high level, fixed link bridge was needed and it opened in 2006.

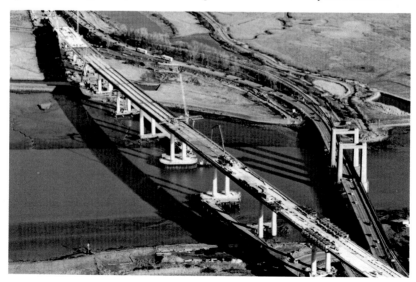

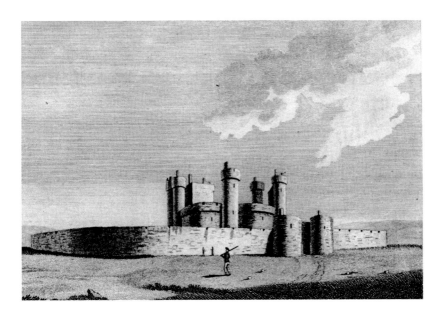

Queenborough, a Royal Favourite

Queenborough is a town built by King Edward III and named after his queen, Philippa of Hainault. It grew, from a small cluster of fishermen's huts on the foreshore known as Binney or Byne, to become the island's principal port. In realising the area's strategically important position in the Medway estuary, Edward built a castle here in 1361. It became the setting for many royal receptions, particularly during the reign of Elizabeth I. By 1650, the castle had become outdated and was no longer viable for our national defences so it was sold for demolition. Today the castle-site is just an obscure grassy mound, the remains of its motte whereon stood the keep; all the stone has been robbed for other buildings in the town. In 2005, archaeologists from the Channel 4 TV programme *Time Team* excavated the site to see what remained of the castle. They found nothing, except for the well, which is capped off. This antique engraving of the castle is one of the few remaining pictures, drawn by S. Hooper in 1787.

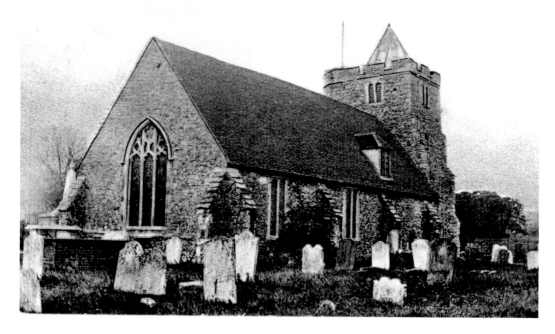

Holy Trinity Church, Queenborough

Another structure built by Edward III is Queenborough's parish church, dedicated to the Holy Trinity and built in 1350 on the foundations of a much older building, which was attached to Minster Abbey; its massive tower was built at a later date than the original church. Admiral Lord Nelson was a regular communicant here. The church was restored in 1886. Although spacious in size, the church has no architectural merit as it has no aisles or side chapels.

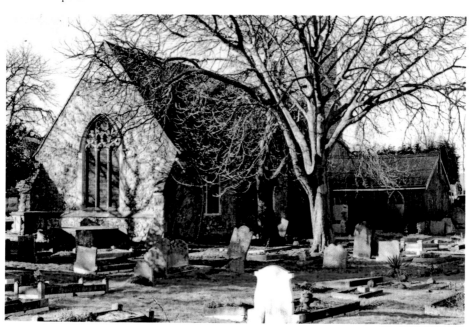

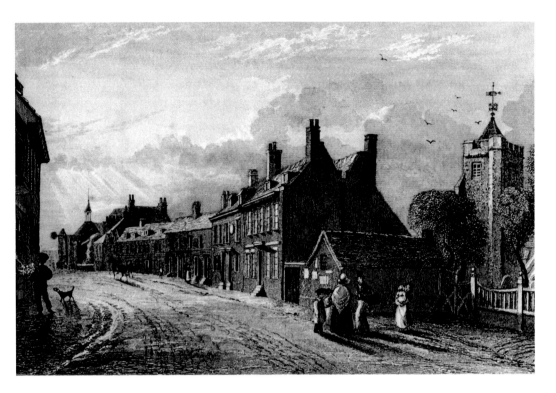

An Unchanged High Street

The High Street has changed little over the centuries as this sketch from around 1830 shows. Fundamentally it's still a single-street thoroughfare that connects the harbour to the castle site. Someone who enjoyed staying here frequently was the landscape painter, Hogarth, who said he found the local scenery inspirational.

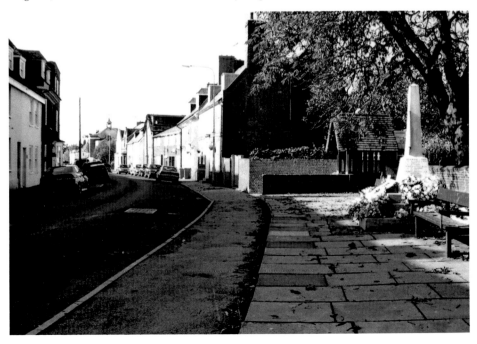

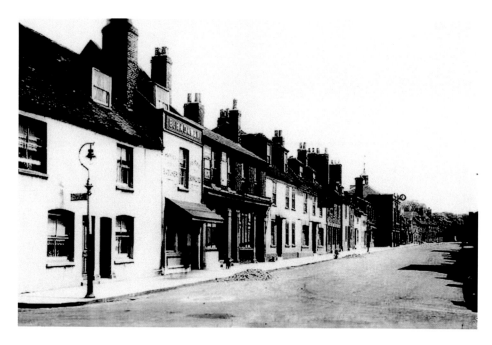

The Guildhall

Occupying a central position in the High Street is Queenborough's Guildhall; its one-time civic centre was built in 1728. After completion it was decided that it would have been better to have had it in line with its neighbouring buildings, so in 1793 it was demolished and the present Guildhall built in its place. Queenborough received a charter from Edward III, placing it under the government of a mayor, two bailiffs, and other officers. It sent two members to parliament from the time of Elizabeth I until disfranchised by the Reform Act, 1832. After the amalgamation of all the island's councils into one unified authority – Swale Borough Council – in 1974, the Guildhall was no longer needed, so it became a museum.

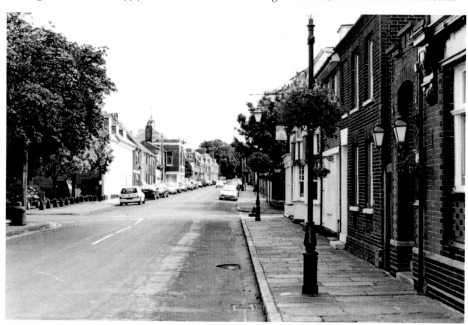

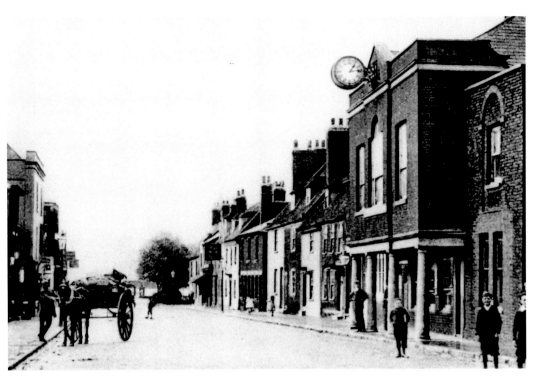

The Guildhall

The Guildhall Museum tells the complex and intriguing story of how this small town's strategic importance became central to the Isle of Sheppey throughout two World Wars and how it has, in the twenty-first century, become a quiet boating and recreational area.

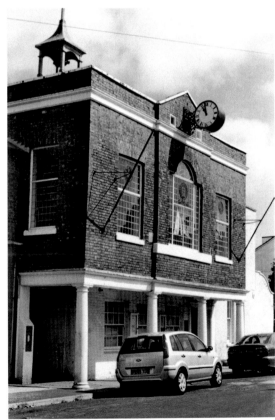

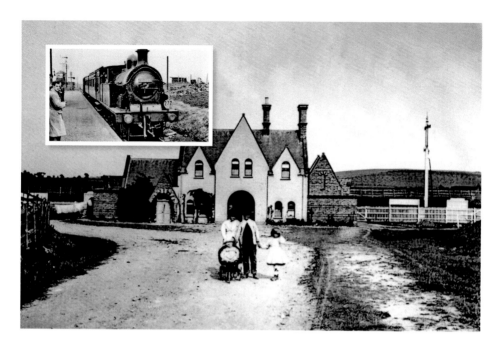

The Railway Station

The railway arrived on Sheppey in 1860, running from Sittingbourne on the mainland to Blue Town via Queenborough, where the station was built on the edge of the castle site. Fifteen years later, a branch line was built, connecting Queenborough station to the town's pier, thus making Queenborough an important centre for passengers and freight bound for the continent. These were the 'boom' years for the town. Queenborough was also 'the end of the line' for the Sheppey Light Railway, which crossed the island, linking Queenborough to Leysdown, and served several of the island's villages *en route*. It ran from August 1901 until 2 December 1950, when it was deemed not to be cost effective due to the dwindling numbers of people using it. Here we see one of the last 'steamers', preparing to leave Queenborough station on that last day.

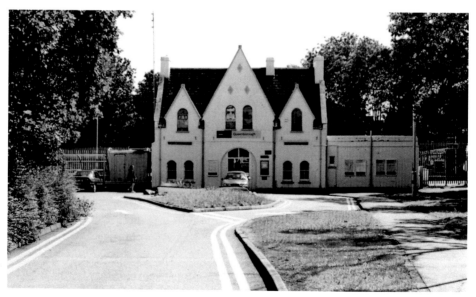

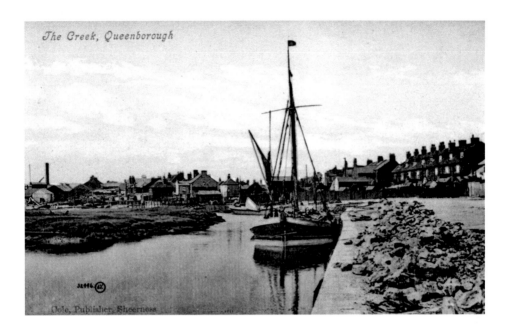

The Creek, Queenborough

Oole, Publisher, Sheerness

The Creek

The settlement that was later to become known as Queenborough was originally known as 'Binney' or 'Byne', a part of Minster until AD 669 when Archbishop Theodore of Canterbury divided England into ecclesiastical parishes. The town grew from just a small group of fishermen's huts, located on the foreshore of the Creek, which at the time belonged to Minster Abbey. Cut off from the main part of Minster some miles away to the east, it is said that upon his arrival here in around 1346, King Edward III created Queenborough as a separate parish, although it was not recognised as such for almost another hundred years. Like the nearby harbour, the Creek today, known as Town Quay, is a favourite haunt for weekend sailors and leisure craft.

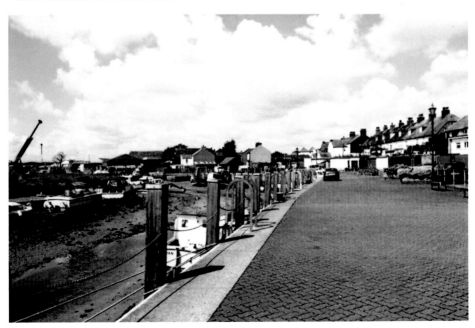

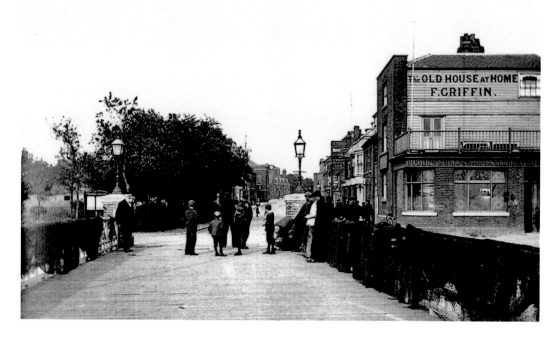

The Harbour

The harbour front today looks remarkably unchanged compared with a hundred years ago and more. The public house, the Old House at Home, is still as popular now as it was in earlier times. It would appear that there have been a few structural changes to the old pub, but its name remains the same.

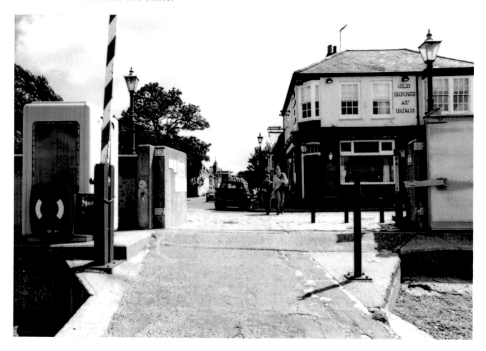

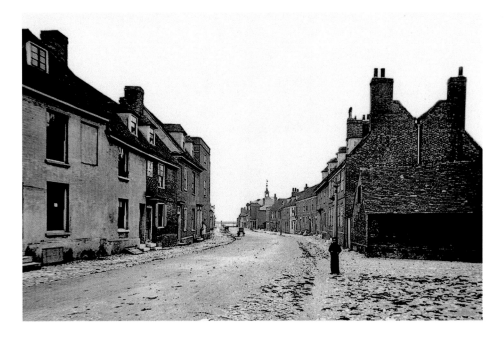

The Road to the Harbour

Queenborough's High Street connects the harbour to the castle site, a route much used by royalty, noblemen, merchants and foreign dignitaries in days gone by. It has changed little over the years and even individual buildings can be picked out in their 'past and present' form. In these two pictures we can see how motor traffic now clogs up the thoroughfare compared with yesteryear when the arrival of a photographer brought this curious child out to see what was going on. In the middle distance can be seen the Guildhall, beyond which lays the harbour.

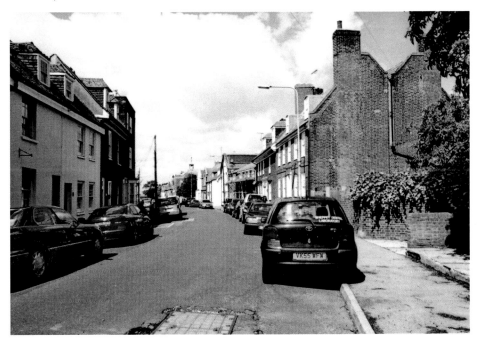

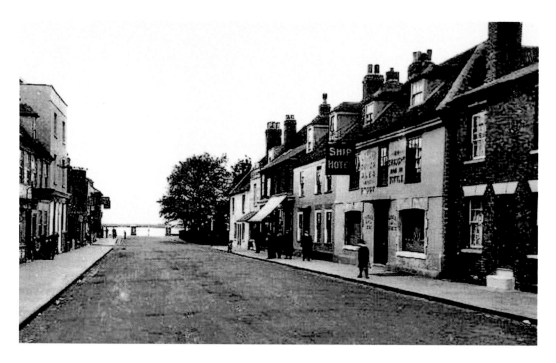

Approaching the Harbour

Near the harbour many of the old buildings have undergone radical changes, such as the Ship Hotel, which appears to have been demolished and a new private house erected in its place – or it could be that the old inn has simply been given a new frontage. Either way, there are many new buildings at this end of the High Street. It is believed wartime bomb damage might have accounted for some of it.

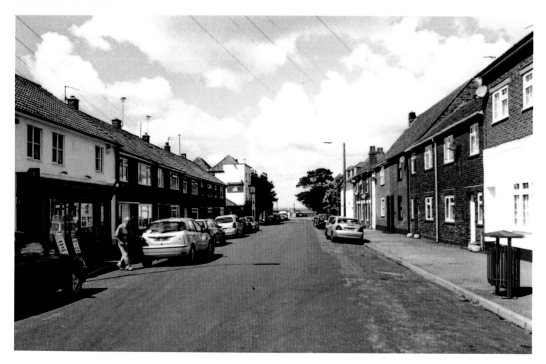

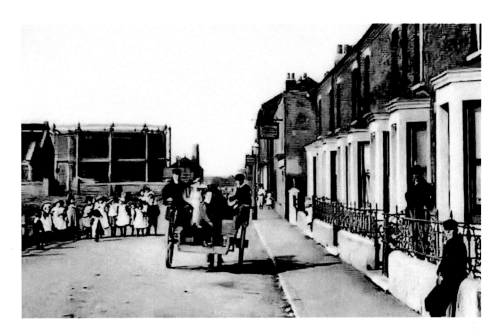

West Minster, a Forgotten Community

An everyday street scene in West Minster, *c.* 1906, with children attracted into the street no doubt, by the presence of a photographer – an unusual sight in those days. Not so uncommon was the milk being delivered by pony and trap. Tradesmen delivered all sorts of goods, like bread, meat and vegetables in this way right up to the late-1940s. In the early hours of Sunday 1 February 1953, a huge surge of water brought on by an exceptionally high tide and gale force winds rushed down the North Sea in a southerly direction, breaching sea defences and flooding all low lying land along the eastern coast of Britain. Sheppey in particular bore the brunt of it. One particular part of the island that was badly affected was West Minster, a small hamlet sandwiched between the railway line and the sea wall between Queenborough and Blue Town.

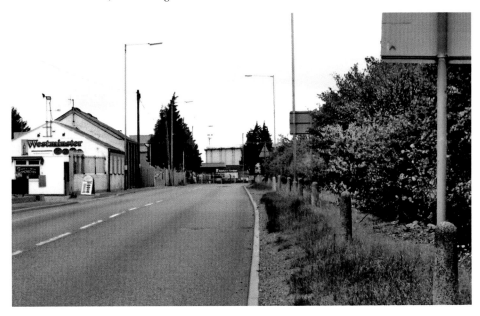

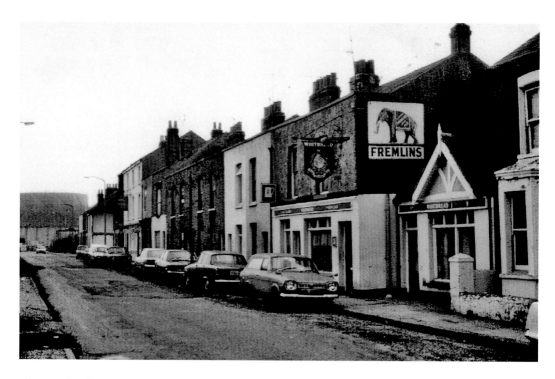

The Hamlet that Once was West Minster

West Minster originally consisted of two blocks of back-to-back houses in Montague Road and Cromwell Road, two pubs – the Globe Inn and the Medway Tavern – a Bethel chapel and a gasworks; its population numbered around 200. Today, the gasworks remain but the rest of the hamlet is waste land, used as a lorry park. The road is now part of the busy A249, which takes traffic straight into Sheerness' industrial area, its docks and the town itself.

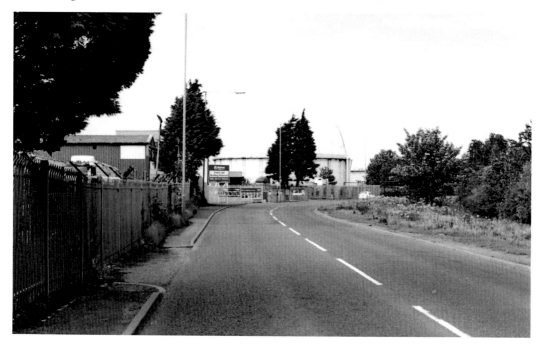

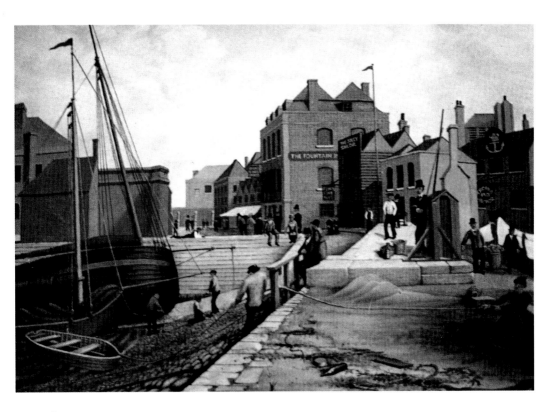

Blue Town

The original town of Sheerness was located at the dockside area, known today as Blue Town. This painting by Harold Batzer shows how it looked in 1830. In comparison, the later photograph looks very similar, and even the Royal Fountain Hotel is still standing.

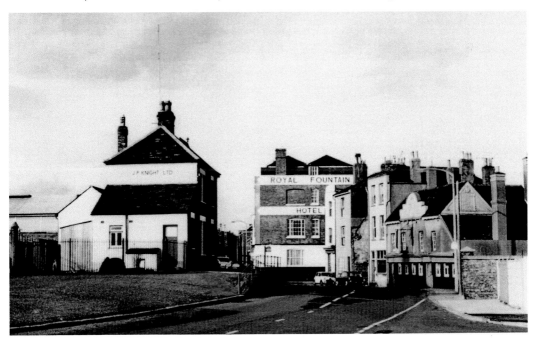

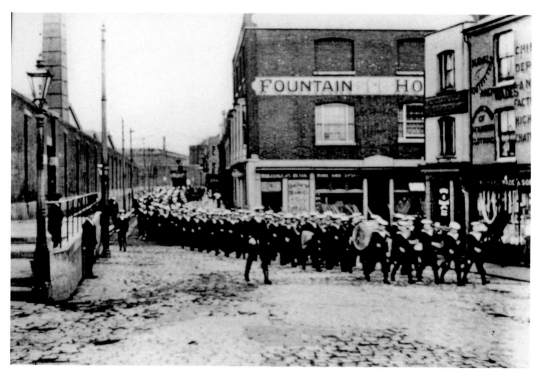

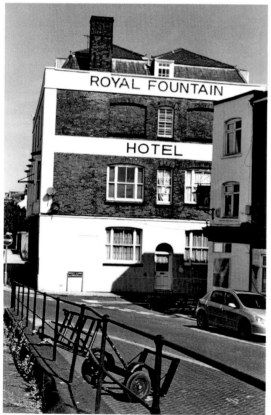

Royal Fountain Hotel

The Royal Fountain Hotel, formerly the Fountain Hotel, is one of the oldest hotels in this part of Sheerness, built in 1812. In its heyday it would have accommodated the Admiralty top brass visiting the dockyard. It is known that Charles Dickens' father, John Dickens, a pay clerk based at Chatham Dockyard, often stayed here when summoned to Sheerness Dockyard. Now no longer used as such, its once-lavish interior has been converted to flats. A typical scene on any Sunday throughout the year would be a detachment of troops, here sailors, on their way to church parade.

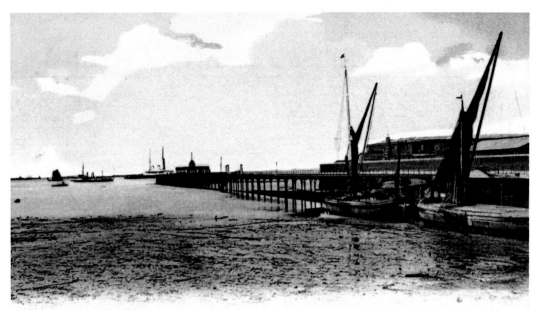

Sheerness. The Pier

The Pier

During the eighteenth century, steamboats were a popular method of travelling down the Rivers Thames and Medway to local seaside resorts. Sheerness was one such resort, with people travelling from London by boat to Sheerness pier, which opened in 1835. The beach, bathing machines (there were eleven in 1861), amusements, bandstands, and other entertainment helped Sheerness become a hugely popular resort. Access to the original pier was blocked off when the docks were redeveloped and the foreshore around the pier was infilled in a land reclamation scheme. Today, all traces of the pier have gone and the foreshore is now a car park.

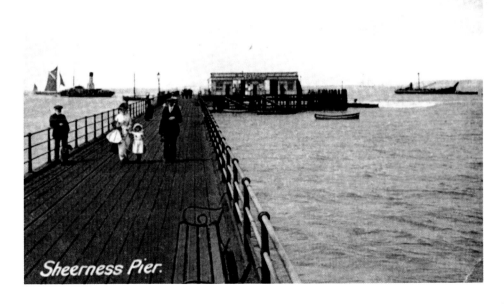

Sheerness Pier.

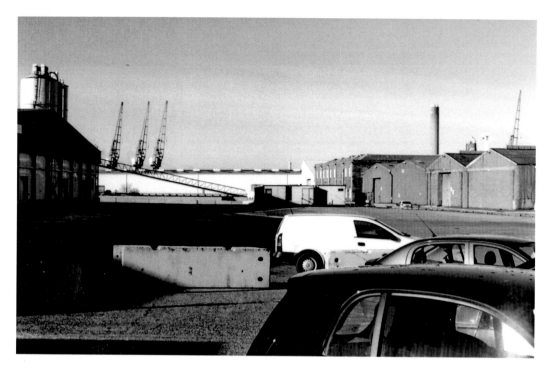

The Pier

The pier would have been a popular place upon which to promenade, watching naval ships and pleasure craft as they sailed in and out of the dockyard. What a pleasant vista this would have offered as visitors took tea at the pier head tea room. Look over the high fence today and you will no longer see the sea but this view of warehouses and car parking. However, a tangible reminder remains, in that the Pier Master's whitewashed house/office is still *in situ*.

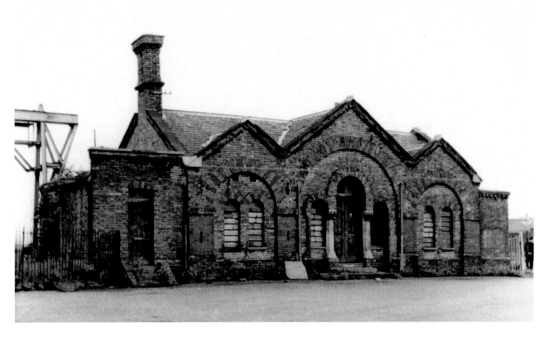

The Arrival of the Railway

The pleasure steamers slowly gave way to the new and much faster train service. Sheppey's first railway terminus, Sheerness, was located in Blue Town, half a mile from what is now the town centre. This station was short-lived, as an extension was built to a more convenient site for passengers in 1883 and called Sheerness-on-Sea station, where the station still stands today. The naming of the new station with the 'on-Sea' suffix promoted the location as a holiday resort, encouraging more traffic down the line; the original station was then renamed Sheerness Dockyard.

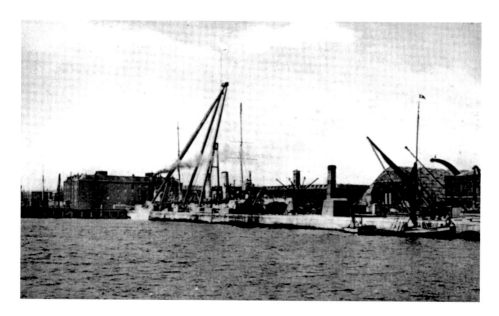

The Dockyard

The Rivers Thames and Medway have long shared the responsibility of sheltering the Royal Navy but from the seventeenth century onwards the Medway began to grow in importance as a naval base. It was realised that Sheerness had great strategic importance because, if a hostile naval force could gain control of the Isle of Sheppey, it would automatically have access to the Royal Dockyard at Chatham via the River Medway, up the Thames into London itself and the vital naval dockyards of Deptford and Woolwich. Maintaining control of Sheerness was therefore recognised as being essential to the Admiralty. Sheerness Dockyard held a strategic position throughout both World Wars, but in 1960, during a period of economic cut-backs, it was decided to close the yard and offer it to the Medway Ports Authority for commercial use. Today, a poignant reminder remains in the shape of a ship's anchor located in Blue Town High Street.

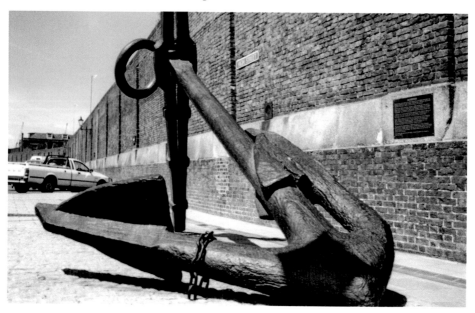

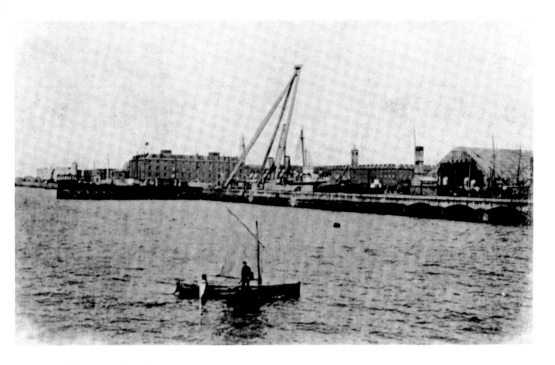

Royal Dockyards, 1824
The postcard caption reads, 'View of the Royal Dockyards of Sheerness looking from Northwards, shewing the state of the works as they appeared in 1824, when the Great Basin and Dry Docks were completed.'

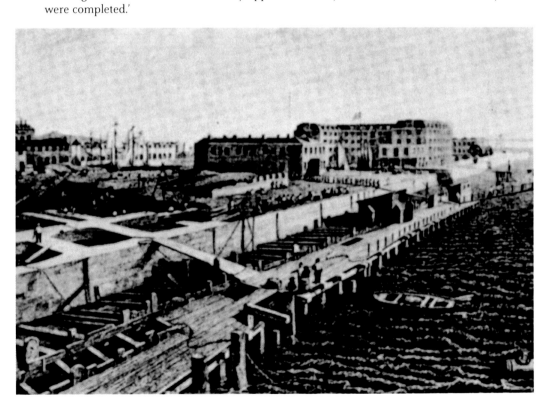

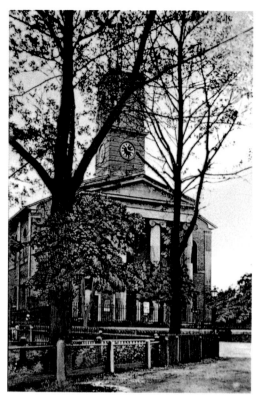

The Dockyard Church

Dedicated to St Paul, the dockyard church was built as the Royal Naval Dockyard Church in 1828 by George Ledwell Taylor, architect for the Navy Board, and Sir John Rennie Snr, engineer. It caught fire in 1884 and, according to a contemporary report at the time, 'The H.M. Dockyard church caught fire. A gale was raging at the time. An hour or two before the outbreak of the fire the streets were almost deserted. A vessel was ashore on the Red Sands with men clinging to the rigging. The fire was possibly started by the heating apparatus when some sparks were blown under the slates and ignited the material there about 8.30 or 9pm. The Dockyard Chapel as it was then called, was on fire. The parapet crashed down at 11pm burying four men, one Pembroke Marsnew, was crushed to death.' The church was rebuilt, reusing the clock tower to a design by Robert Wheeler of Tunbridge Wells in the Byzantine style. After the closure of the dockyard in 1960 it was no longer needed and after being deconsecrated it became a squash court and community centre. In more recent times it was purchased by a property developer.

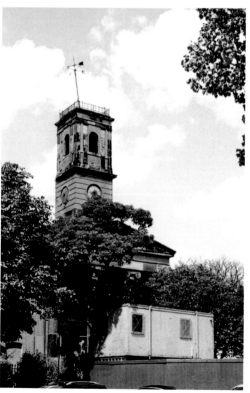

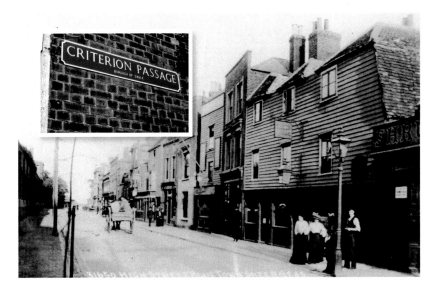

Blue Town High Street

Blue Town as a town never had any pretensions of grandeur. Its finest houses were located within the dockyard, reserved for the important military people. Those living outside in the High Street lived in buildings of timber construction – timber being more readily available and cheaper than stone or brick. It ran the risk of fire damage though and, in 1827, a major fire destroyed between fifty and sixty buildings. Another fire broke out in 1830, destroying a further fifty buildings. One of the principal places of entertainment in Blue Town was the New Palace of Varieties music hall, at the rear of the Criterion Hotel, where many well-known performers of the 1870s began their careers. It began as a small theatre situated at the rear of the Mitre inn and later expanded into these much larger premises. Today's frontage is somewhat different to the original, after being been struck by a bomb during the war and succeeding different uses such as a car repair workshop and boat building to name but two. The Criterion is now home to the Blue Town Heritage Centre.

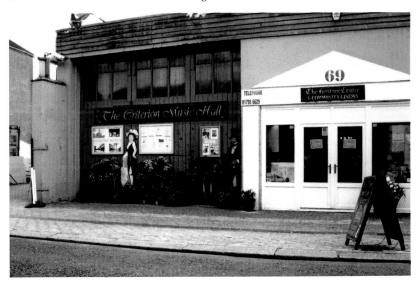

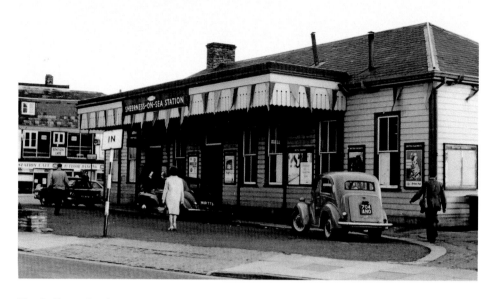

The Railway Station

As the size of Blue Town gradually grew, its population spilled over to an adjoining area, firstly known as Mile Town, a name acquired from the dockyard, which stipulated that all of its employees must live no more than one mile from the dockyard gate. The official naming of the area as Sheerness-on-Sea came into being in 1883 with the opening of a new, more conveniently placed railway station. This was how the town's railway station looked until 1950 when an incoming train overshot the buffers, leapt through the booking hall and ended up on the pavement in front of the station. Mercifully, only one person was killed but seven others were injured. Such was the damage caused to the wooden building that the entire station had to be rebuilt.

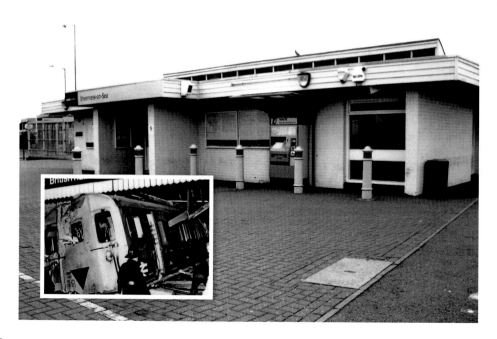

A Memorial to Two Tragic Accidents

As visitors leave the railway station and cross the road, heading for the sea front, they cannot fail to see the large white statue of a toga-clad lady clutching a blazing torch – or ice cream cornet depending on your point of view! It commemorates two First World War naval disasters. On 26 November 1914, the battleship HMS *Bulwark* exploded whilst at anchor in the River Medway close to Sheerness Dockyard with the loss of 600 lives. The cause of the explosion was said to be connected to the ship's magazine. Then, on 22 May 1915, the minelayer HMS *Princess Irene* suffered a similar fate but with an even greater loss of life: 1,078 officers and men, and 76 shipwrights, riveters and boys who were working onboard at the time. On this occasion, mines were being prepared for laying and the cause of the disaster was thought to have been due to a faulty primer. However, evidence at the Official Enquiry showed that the work of priming the lethal mines was being carried out in too much of a hurry and by untrained personnel. The memorial was unveiled on 29 April 1922 and was funded by public subscription.

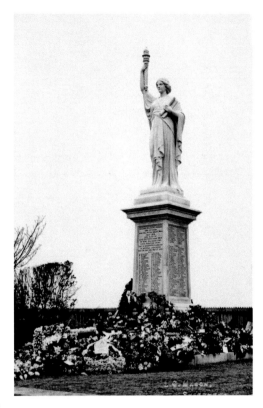

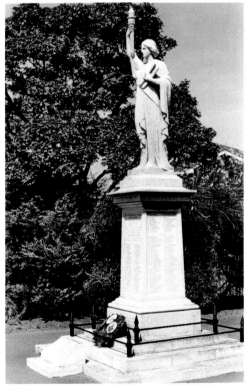

29

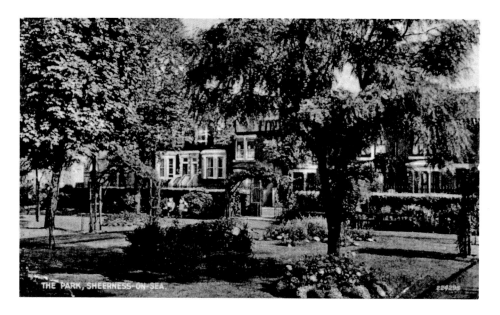

THE PARK, SHEERNESS-ON-SEA.

Beachfields Park

As day-trippers and holidaymakers left the railway station and crossed the road, ahead lay the beach and funfair. To get there they would have needed to pass through Beachfields Park. Who remembers the Second World War mine that served as a collection point for one charity or another that stood at the park entrance for many years? Today it's been replaced by a modernistic sculpture. Originally coastal marshland, Beachfields Park provided a green oasis between the town and the sea, but it has been systematically encroached upon by development. The park's original boundary started at the defensive moat at its western end and finished at the Catholic church on the Broadway. It now starts at Holland's Amusement Park following Tesco buying a portion of the land for a new store in 1993. Beachfields Park was left as a recreational area because it was prone to flooding, even after flood protection was improved along the beach and this area has stayed one of the main recreational areas in Sheerness.

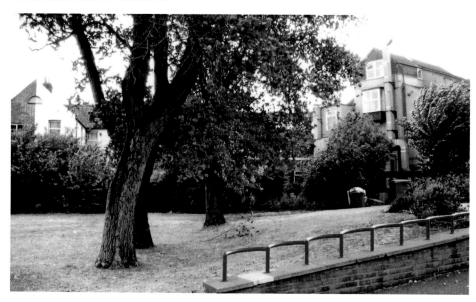

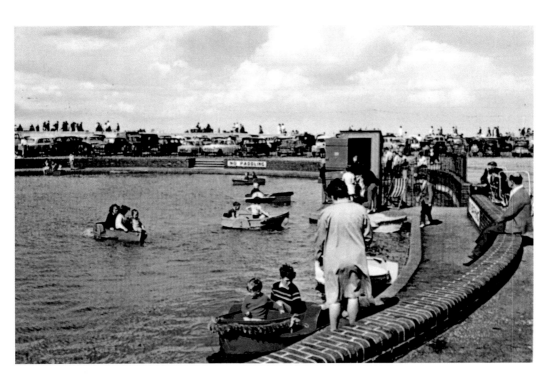

The Boating Lake

On their way from the railway station to the seafront, visitors had to pass by the boating lake, a prerequisite entertainment for most Victorian and Edwardian children. It was constructed in 1925 with the first wooden pedaloes being named after local councillors. Should anyone get into difficulty, there was always an attendant in a white coat standing by, ready to help. The boating lake remained in use until the 1980s but is now a children's sandpit.

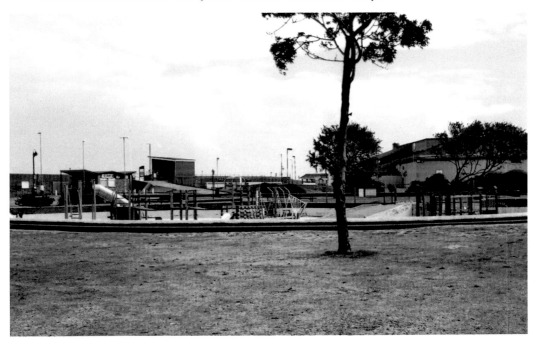

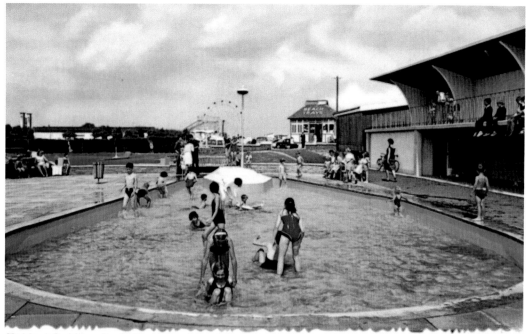

Kiddies' Paddling Pool, Sheerness, Isle of Sheppey. ET.4704

The Paddling Pool

To the east of the boating lake, set behind the swimming pool, was a small paddling pool for children, as can be seen in this 1970 view. Today much of this area has been taken over by the Sheppey Leisure Complex. Just a few short years separates these two pictures of the paddling pool and the boating lake but look carefully at how much the skyline has changed. In one, the funfair has gone, replaced by a supermarket, whilst in the other, the sea wall is much lower.

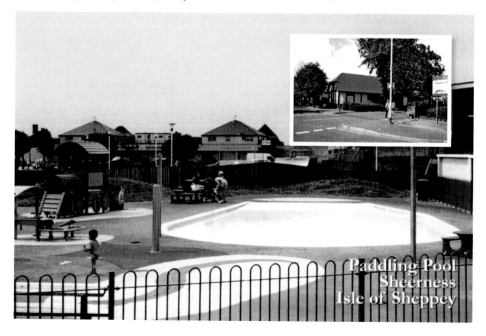

Paddling Pool
Sheerness
Isle of Sheppey

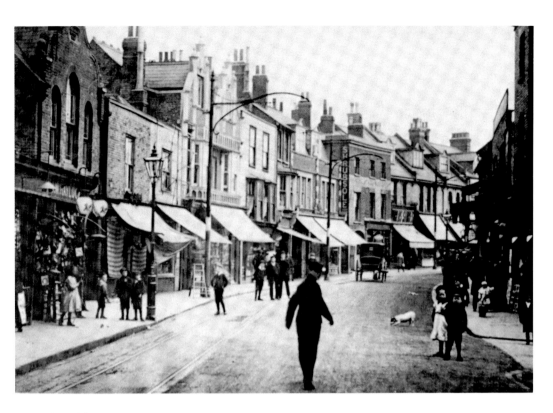

The High Street

Sheerness High Street runs roughly east–west from the railway station. In all of its hundred-year history, it has changed very little in appearance, as can be seen in this view, *c.* 1875. At its junction with the Broadway, in an area known as the Crescent, the town's clock tower can be seen.

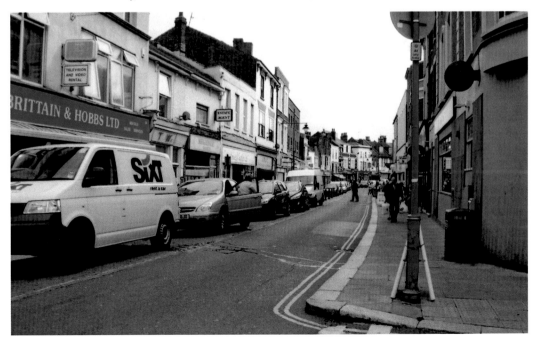

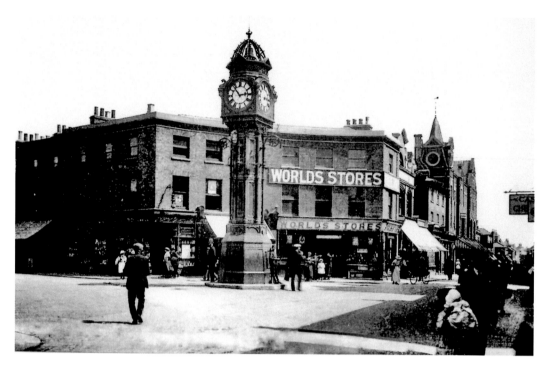

The Clock Tower

Central to Sheerness High Street, where the Broadway heads off, following the coastline to Minster – an area once known as the Crescent – is this fine clock tower. It was erected in June 1902 at a cost of £360 to commemorate the coronation of King Edward VII and Queen Alexandra.

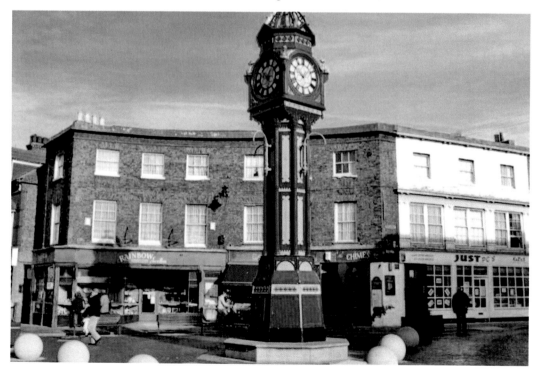

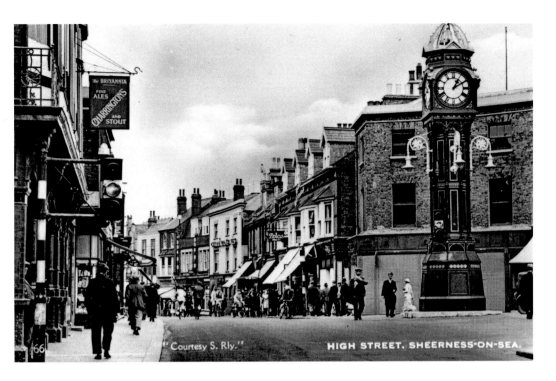

HIGH STREET, SHEERNESS-ON-SEA.

An Old Coaching Inn

At the junction of the High Street and the Broadway, by the clock tower, stands the Britannia Hotel, a former coaching inn said to be the oldest licensed premises in Sheerness. Rebuilt in 1891, it once stood in complete isolation, out on the marshes, well beyond the original town of Blue Town. Naval heroes like Nelson, Howe, Troubridge, Collingwood and Saumarez often stayed here whilst ashore and their names can be seen in the hotel's old register.

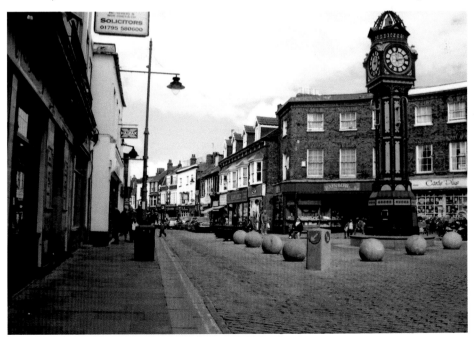

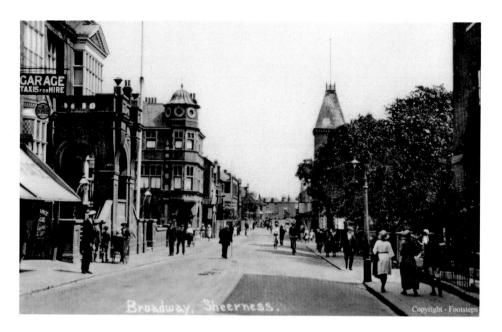

The Broadway

The Broadway was designed and built by Sir Edward Banks in 1827. Here he built a magnificent mansion, not for his own use but that of the Commander-in-Chief of Nore Command. However, it was never used for this purpose and later became the Royal Hotel, which was demolished in the early 1930s to make way for the Rio cinema – itself demolished in 1990 in favour of residential flats, Royal Court. Banks' work, which included fashionable town houses in Banks Terrace and a proposed pier near the Royal Hotel, turned Sheerness into a prosperous seaside resort that attracted people of wealth and elegance. However, his grandiose plans were thwarted by the Oyster Fisheries Commission and several leading citizens, causing Sheerness' popularity to slump for the next twenty years. Today, the grand, sweeping vista that is the Broadway is marred by unsightly, modern, garish street furniture.

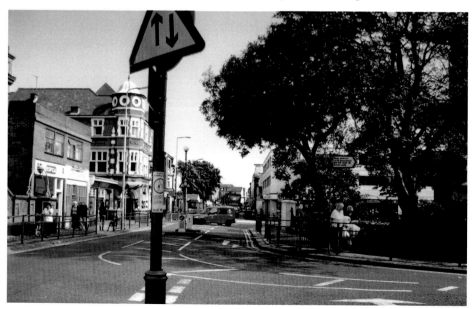

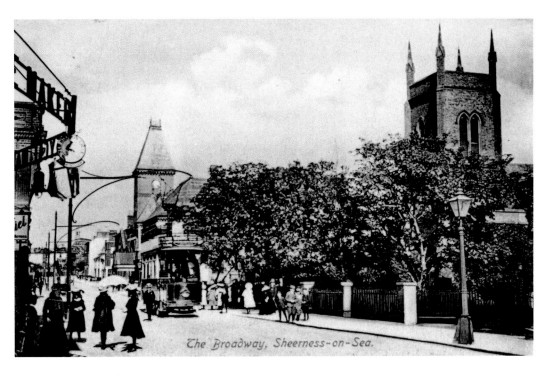

The Broadway, Sheerness-on-Sea.

Holy Trinity Church

Built in 1836 to a design by G. L. Taylor, Holy Trinity church is situated in the Broadway. It is a typical example of the churches erected during the Victorian church-building programme of the nineteenth century. See how much more cluttered the street is today with street furniture, increased traffic, ever-growing foliage, etc.

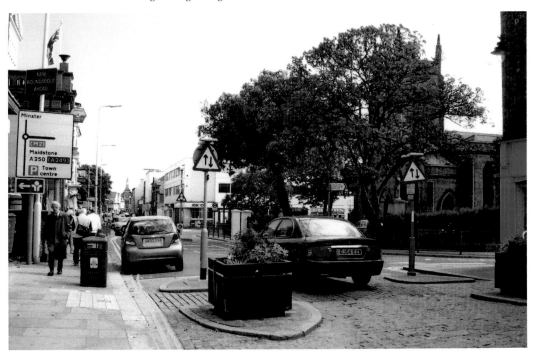

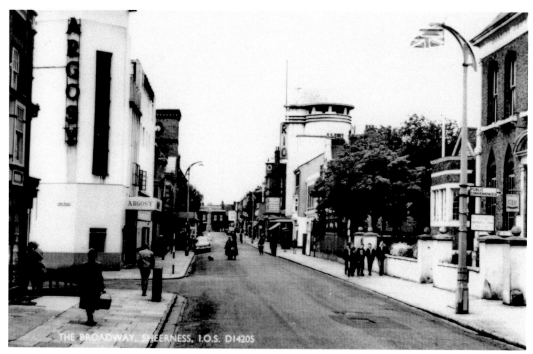

THE BROADWAY, SHEERNESS, I.O.S. D14205

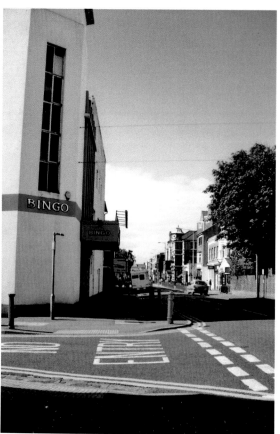

Sheerness' Former Cinemas

Once there were three cinemas in Sheerness, one of which was the Argosy in the Broadway. It also featured live entertainment on its stage on Sunday evenings in the 1950s but in the face of dwindling audiences in the 1960s/70s, like many of its contemporaries, it sold out to bingo operator Ladbroke's. The Argosy opened during the era of building larger, more luxurious cinemas on 29 January 1936. Designed by the cinema architect of the day, F. E. Bromige, it had a striking octagonal corner tower as its main design feature. Next door to the Argosy was the Hippodrome theatre. Another architecturally striking cinema standing almost opposite was the Rio, which was demolished in 1990 to make way for a block of flats. Today, only the Argosy remains as a bingo hall.

Sheerness Heritage Centre

It was originally hoped that Sheerness would become a smart and well laid-out town, but instead, with an increasing number of dockyard workers settling here, it became a hotch-potch of drab utilitarian buildings connected by a maze of alleys. Today, most of these buildings have been replaced with better quality housing, but an example of one of those old dockyard workers' cottages remains in Rose Street, where the town's Heritage Museum can be found.

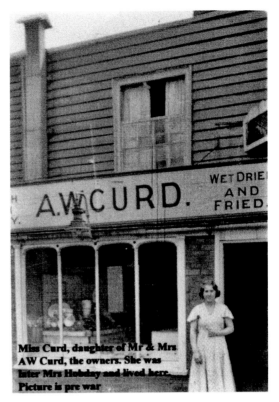

Miss Curd, daughter of Mr & Mrs AW Curd, the owners. She was later Mrs Hobday and lived here. Picture is pre war

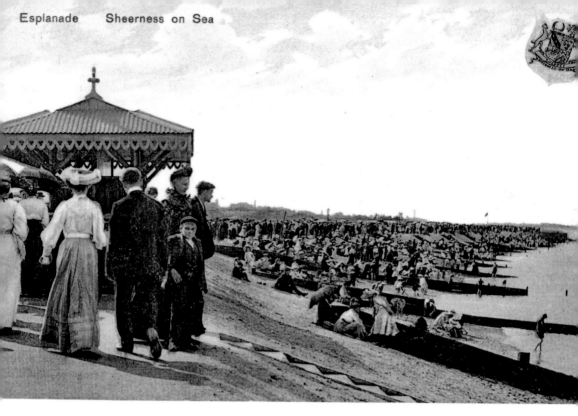

Sheerness Seafront

Proof, if proof is needed, of how popular Sheerness beach once was. The earlier picture of 1908 compares well with the later view of 1970.

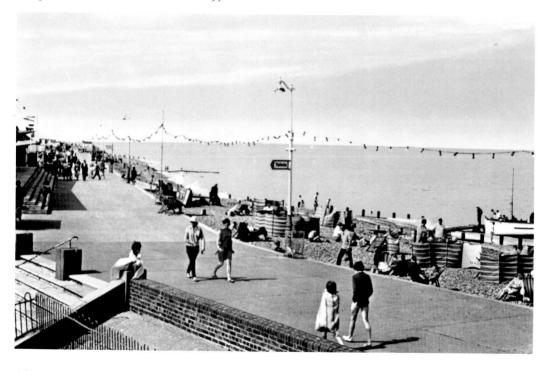

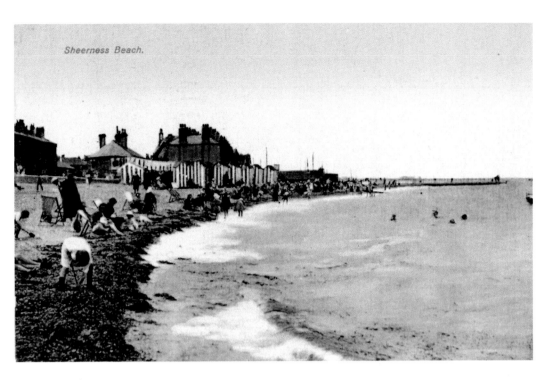

Sheerness Beach.

The Beach

Sheerness' long, sweeping beach was once packed with holidaymakers and day-trippers. Changing huts were placed at intervals along the beach, as seen in this 1932 view. Today it's a very different scene with few day-trippers and no changing huts. Stretches of the beach are so little used that grass and weeds have begun to invade.

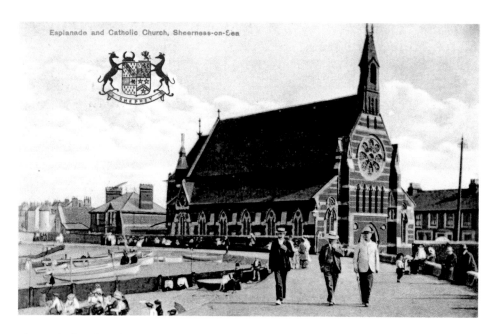

The Catholic Church

One of the most beautiful of all the churches on the island is the Roman Catholic church in the Broadway, standing almost on the sea wall. It is dedicated to SS Henry and Elizabeth, and was designed by Pugin the Younger in 1865/66. It is said that the building of the church was funded by Colonel Moysten of the North Cork Militia, who were posted to Sheerness. Each Sunday the Colonel led his men to the old Catholic church in Rose Street – where it had stood since 1790 – to celebrate Mass, but as the building was so small, the troops had to kneel in the road. Moysten was so impressed by his men's devotion he paid several thousand pounds to have a larger church built, including a school and a house for the priest. There is a memorial tablet dedicated to the colonel and his wife in the church.

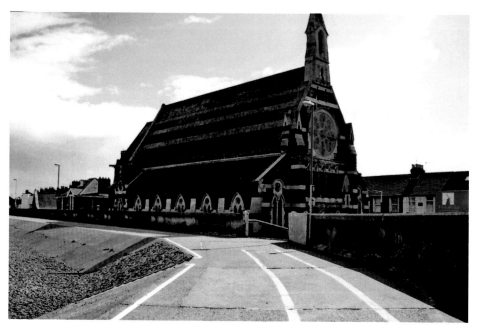

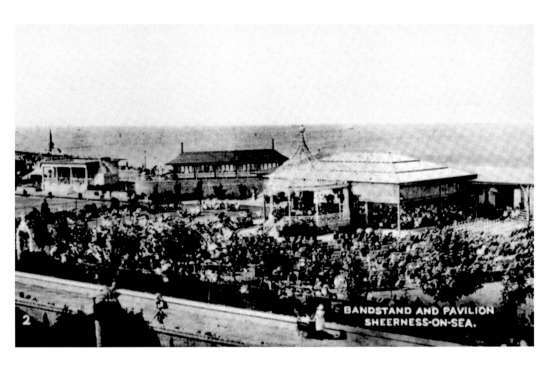

BANDSTAND AND PAVILION
SHEERNESS-ON-SEA.

Leisure Centres Old and New

In their leisure time, the Edwardians and Victorians liked nothing better than to sit in the sunshine and listen to a band, or play a gentle game of tennis or bowls. Today we crave the more strenuous exercise offered by gyms, indoor, heated swimming pools and the suchlike, which is mirrored in the change of architecture. How tastes change...

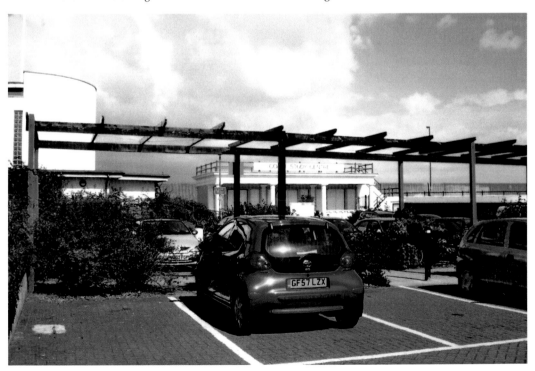

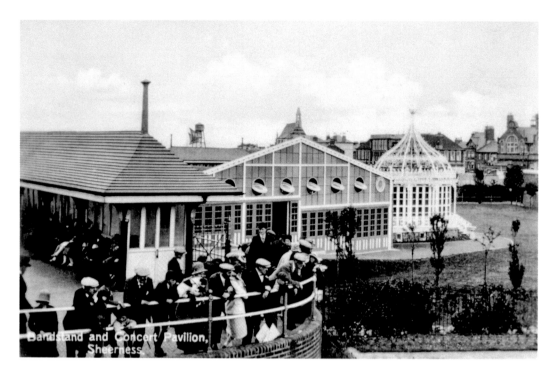

Bandstand and Concert Pavilion,
Sheerness.

The Bandstand and Pavilion

The first bandstand to be built stood in Beachfields Park and commemorated Queen Victoria's diamond jubilee in 1897. It coincided with a new entrance to the park via Jubilee Stairs near Royal Road. It was rebuilt in 1923 but the entire site was demolished in 1953 following severe flooding. In its place today stands a multipurpose leisure centre.

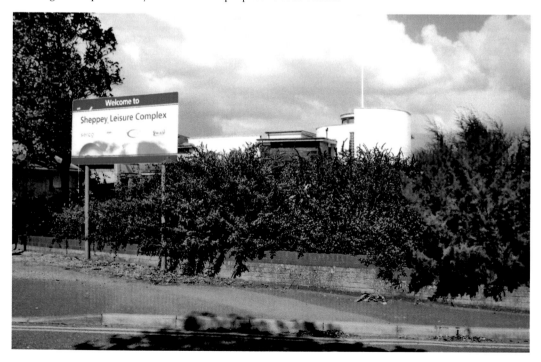

Welcome to
Sheppey Leisure Complex

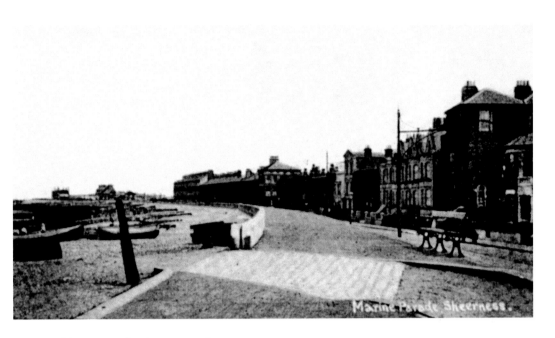

Looking Towards Cheyney Rock

Looking eastwards towards Cheyney Rock, the owners of these terraced houses once had splendid sea views. However, rising sea levels caused by climate change has necessitated the sea wall being increased in height and today the view can be likened to that of the former sector of East Berlin where all some people could see was a solid wall.

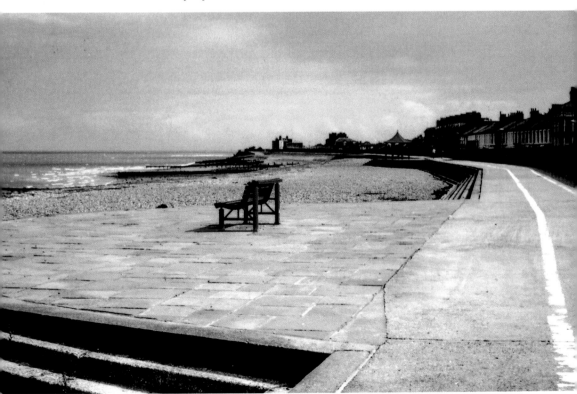

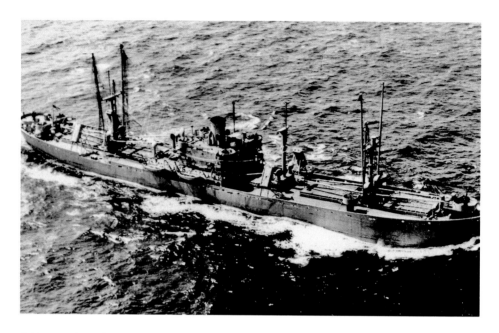

A Famous Wreck

Something many visitors flock to Sheerness to see is the wreck of the US Liberty Ship, *Richard Montgomery*, which is clearly visible from the beach, especially at low tide. At one time, pleasure boats took visitors on a trip 'around the wreck'. Towards the end of Second World War, this ship was laying at anchor, fully loaded with munitions, ready to set sail for the Normandy invasion beaches, along with many others. As the tide fell she went aground on a sandbank and broke her back. Some of the munitions were unloaded before the ship sank, but much of the cargo still remains aboard. Regular inspections of this lethal cargo are carried out and the wreck is now in three sections with much spilling out on to the sea bed. It is now deemed to be too dangerous to handle and hopefully a combination of time and the sea will render the cargo safe.

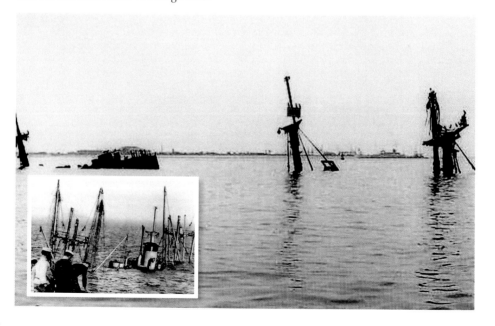

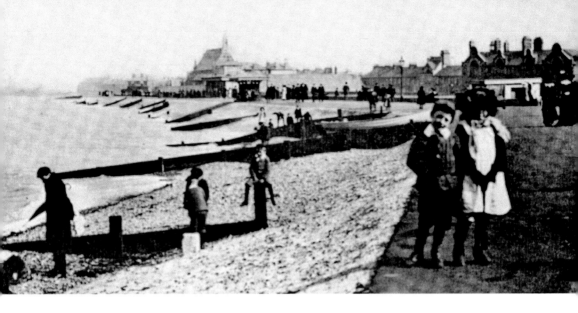

'All aboard the *Skylark*!'

Throughout the 1960s and 1970s, local boatmen took day-trippers out to the wreck of the *Richard Montgomery* in boats such as this one. As can be seen, Sheerness beach was a popular place, more so than the earlier 1905 view. Children posing for the camera? It was more likely to have been inquisitiveness that drew them to the photographer.

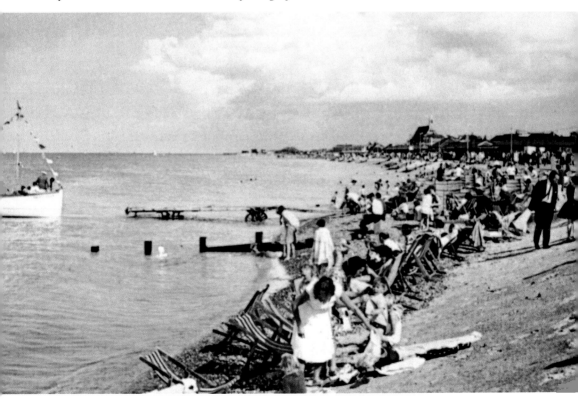

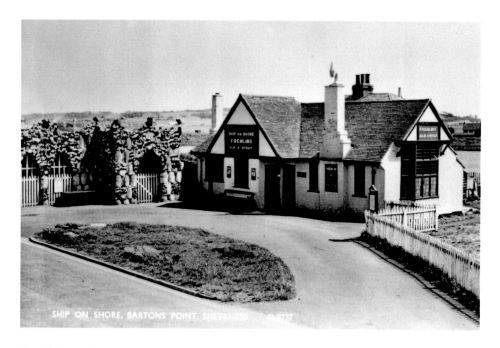

The Ship-on-Shore Grotto

Beyond the town of Sheerness, on the coast road to Minster at Cheyney Rock, is a small pub called the Ship-on-Shore. Outside it has a curious-looking grotto. It is said that, at the turn of the twentieth century, a cargo ship carrying cement was shipwrecked nearby and its barrels of cement, set rock hard by the sea water, littered the foreshore. The publican of the Ship-on-Shore built the grotto with these barrels, persuading the locals to help him move them – no mean feat as each one took four men to lift. He added shells and stones also taken from the beach, and created the grotto, which became something of a crowd-puller to his pub.

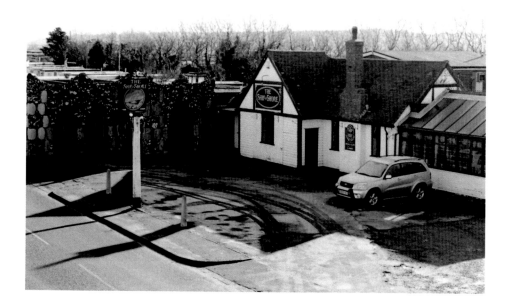

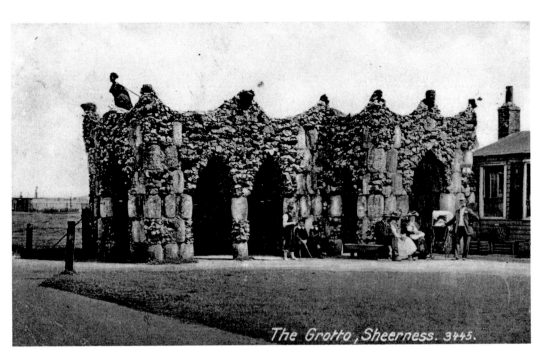

The Grotto, Sheerness. 3445.

The Grotto Close Up

This close-up of the grotto clearly proves the story of its construction using solidified barrels and sea shells; only the origin of those barrels remains an enigma. The pub itself had once been a coastguard station but later, at an unknown date, the wooden building was purchased by Flint & Co. for use as licensed premises.

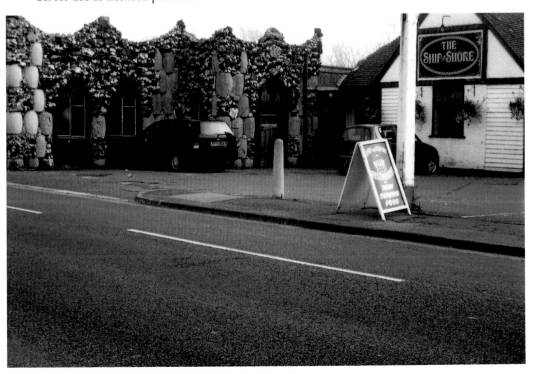

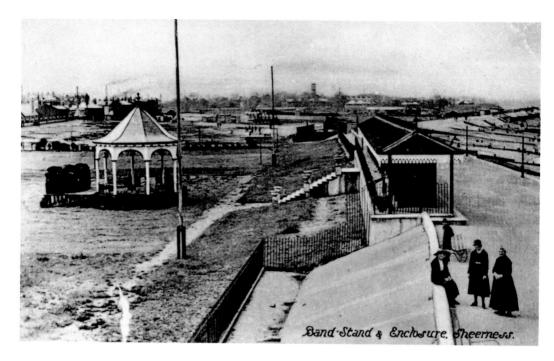

Band-Stand & Enclosure. Sheerness.

An Edwardian Promenade

Compared with later views of the seafront, it is virtually deserted in this early Edwardian view. This particular picture is one that caused some concern. In the early view see how far away the factory chimneys and the dockyard clock tower appear to be. In today's view they are all much closer – and yes, the same viewpoint was used. Furthermore, where did yesterday's lensman stand to get this elevated view? Whatever it was, there are no remaining traces of it today. To the left of the early view the original bandstand can be seen, which was replaced by a larger one in the summer of 1924.

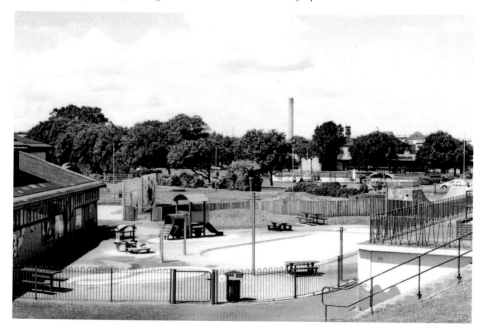

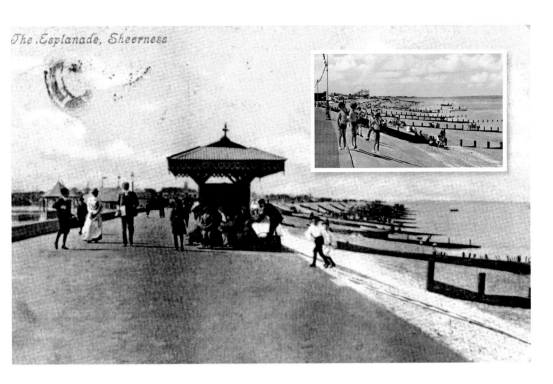

Genteel Days at the Seaside

In the Edwardian days, as seen in these two 1906 views, day-trippers' and holiday-makers' needs were simple. They did not need all the trappings today's youngsters crave. A clean beach, a bandstand, a promenade and a shelter – and perhaps a go cart – they were all that was needed for a good time. Even on a hot summer's day, the Edwardian bathers shed few of their clothes, but moving on fifty years to the 1950s see how beach fashions have changed, with much more of the body being exposed to the sun.

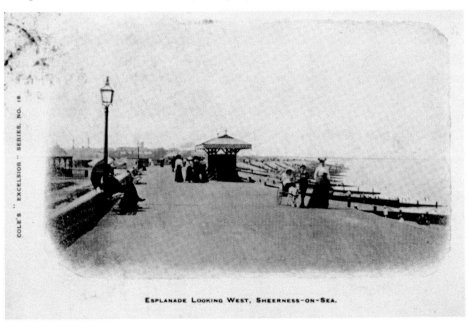

ESPLANADE LOOKING WEST, SHEERNESS-ON-SEA.

51

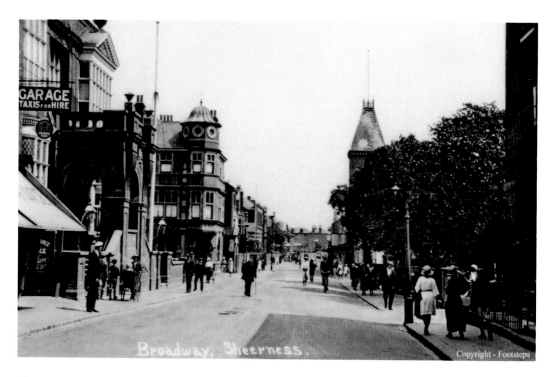

The Broadway

Taken *c.* 1910, this is the Broadway, Sheerness' once salubrious road, designed for the well-heeled. It was originally known as Edward Street after its designer, Sir Edward Banks. He had another road named after him – Banks Terrace. Whereas in those days pedestrians dominated the streetscape, today this road is a busy route, taking traffic out of Sheerness and on to Minster.

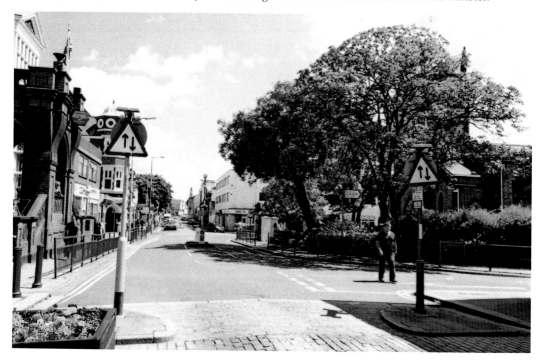

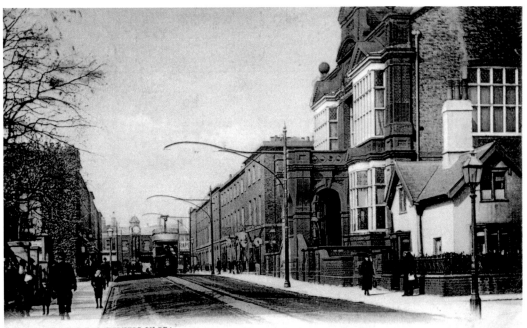

EDWARD STREET, SHEERNESS-ON-SEA.

Cole's Colored Series.

The Conservative Club

Looking back up the Broadway – or Edward Street – towards the clock tower and the High Street in 1904, to the right can be seen the imposing building that is Sheerness Conservative Club.

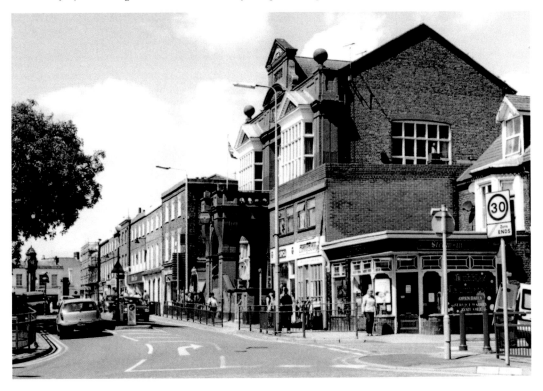

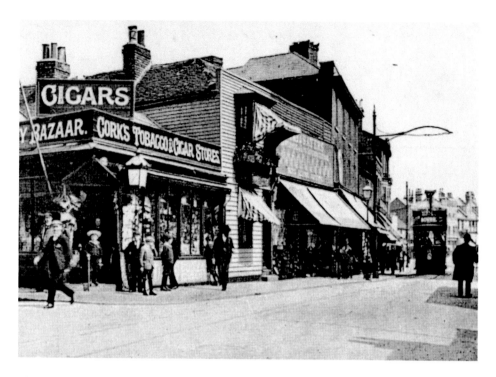

The High Street

One noticeable difference in the High Street today is the volume of traffic passing through. This is Cork's tobacco and cigar store at Nos 16 and 18, on the corner of Beach Street, *c.* 1907. The shop was also a fancy goods bazaar. A solitary tram passes through where today there is a never-ending stream of vehicles as they queue for the traffic lights, out of view behind the photographer.

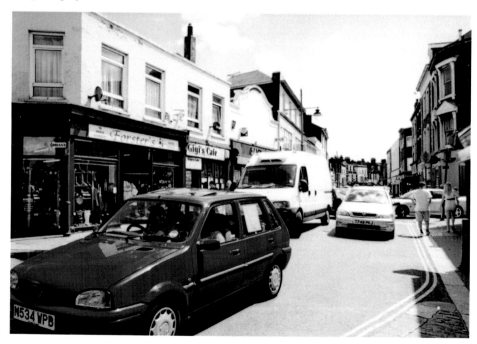

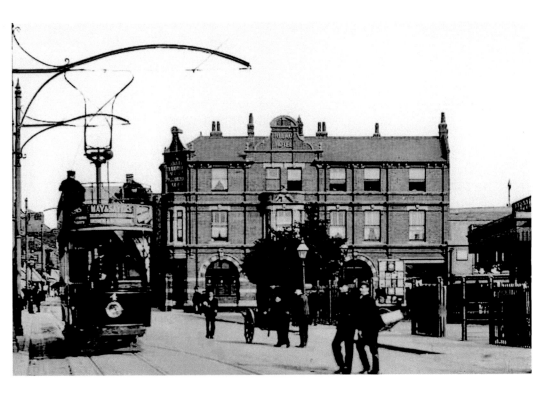

The Railway Hotel

At one time almost every town had a Railway Hotel close by its railway station and Sheerness was no exception. Today it is a trendy pub known as Bar One but its exterior has changed little since around 1908 when this picture was taken. To the left of the modern-day view, it can be seen just how congested the High Street is.

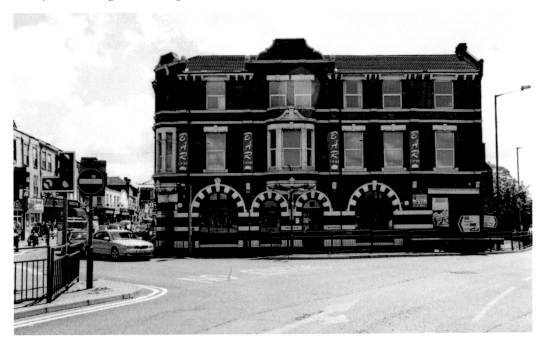

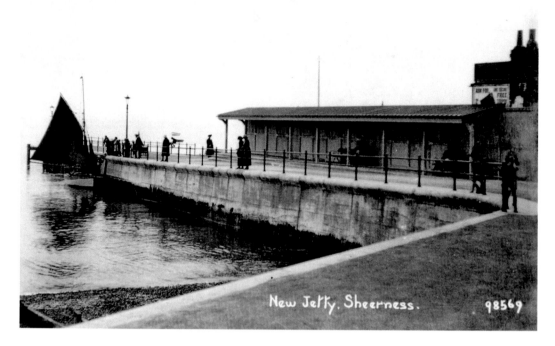

New Jetty. Sheerness. 98569

The New Jetty

This stone-built jetty, seen here in around 1925, used to be a favourite spot for little boys to fish, using a hand line that they probably bought in town. It was an essential part of any holiday. Being so close to the shore though, it is doubtful whether they caught anything. Sad to say, today the shelter has gone, possibly once a popular spot for nurturing holiday romances.

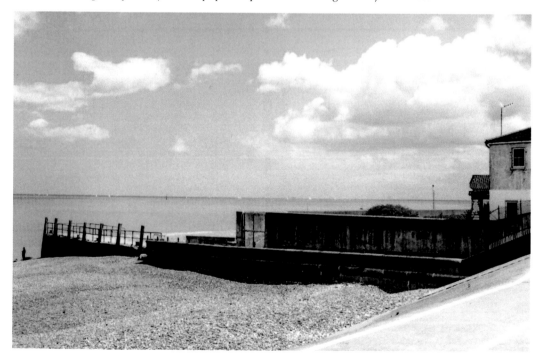

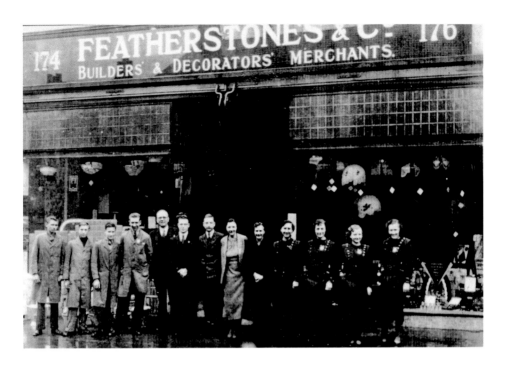

Shopping, Yesteryear Style

Nos 174–176 High Street was once the builders' and decorators' shop, Featherstone's & Co. See how smartly and appropriately dressed each member of each level of staff was. It is not difficult to pick out the shop manager, the salesmen, the lady cashier and the porters, but the mystery remains, what role did the ladies dressed like cinema usherettes perform? Today this same shop, looking markedly different, is KC Carpet Warehouse.

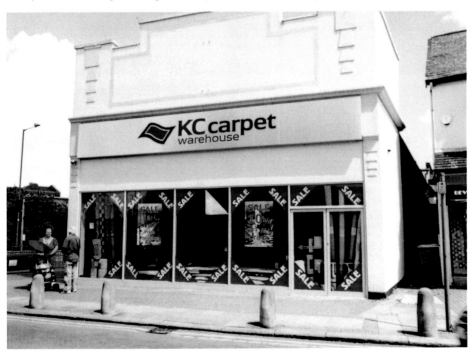

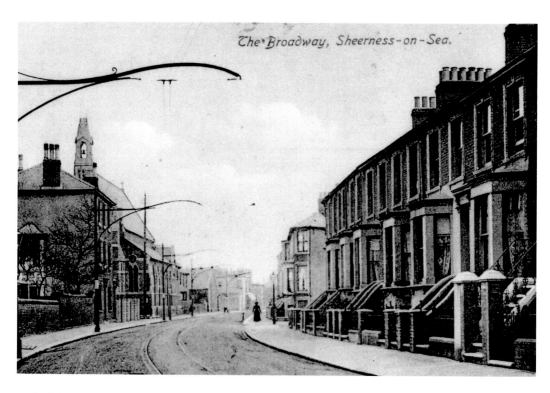

The Broadway, Sheerness-on-Sea.

End of the Broadway
The Broadway ends by the Roman Catholic church, after which the vista opens up to expansive sea views along Cheney Point.

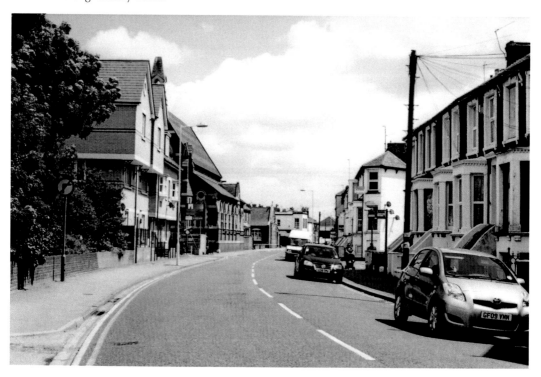

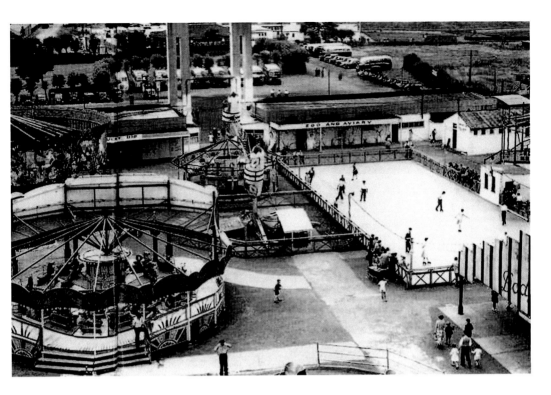

The Funfair

As visitors and day-trippers made their way from the railway station, through Beachfields park to the seafront, few could resist calling in to Hollands amusement park, a site now occupied by Tesco supermarket.

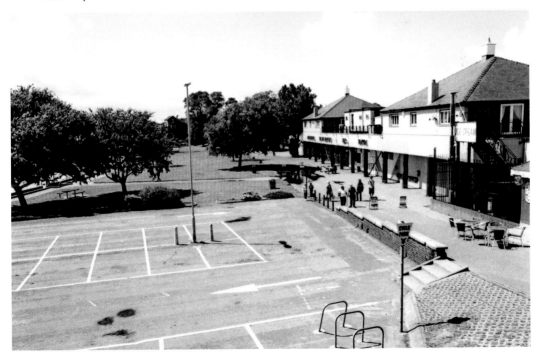

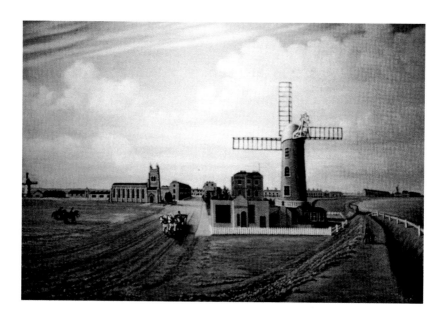

The Banks Town Windmill

Originally there were four windmills on the island and this was one of them, the 100-Acre – or Ride's – mill, which was constructed in the eighteenth century. This painting of how it looked in 1836 is the work of Harold Batzer. Today, only the brick base remains, tucked away between two large buildings in the Broadway. This was the heart of Sir Edward Banks' proposed new suburb but as more buildings were built, it robbed the windmill of much of its driving force. Two such buildings were the Seaview Hotel and the Roman Catholic church, whose owner, Mr McKee tried unsuccessfully to sue for robbing him of an easterly wind. At one stage in its life the owner rented it to Henry Ride and it became known as Ride's windmill. The windmill was demolished in 1872 but the brick-built base was retained as a store for the adjacent hotel. With the hotel itself now demolished and a block of flats built on the site, the windmill's base still remains but for what purpose it is not clear.

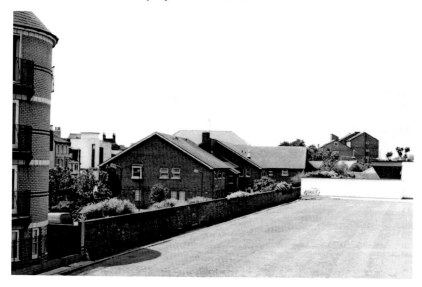

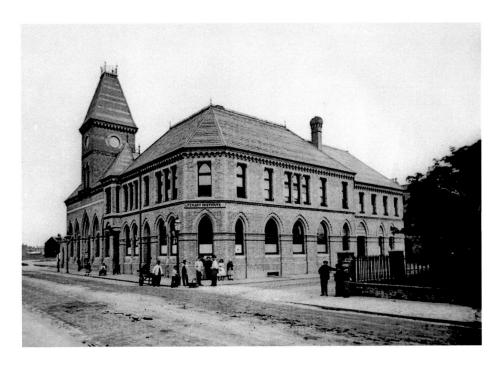

The Hippodrome Theatre

Built in 1872, this once magnificent theatre attracted many of the star names of the stage in its heydays. The Hippodrome was originally known as the Victoria Hall until the Victoria Working Men's Club was built almost opposite the theatre. In 1920 it became a dual-purpose cinema and variety theatre. A regular visitor to the theatre was Carroll Levis who toured the country in the 1950s and 1960s with his well-known Talent Shows; he was the Simon Cowell of yesteryear. The theatre was demolished in 1970 and today the site has been developed into an HSBC bank.

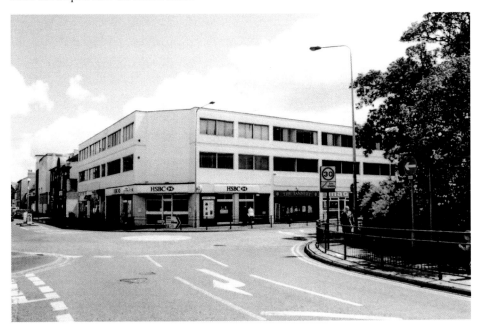

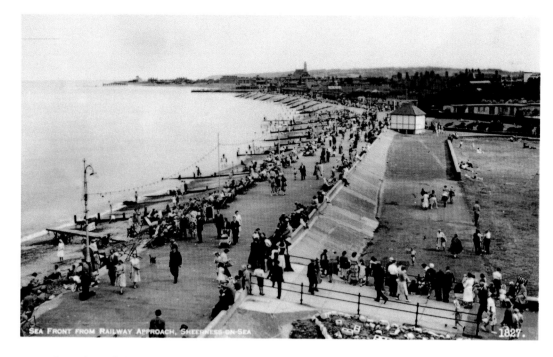

SEA FRONT FROM RAILWAY APPROACH, SHEERNESS-ON-SEA 1827.

First View of the Beach

This would have been the first sight of the sea and the beach that many would have enjoyed once they had left the railway station. Today the route is still very much the same but see how much higher the sea wall has had to be built to counteract today's rising sea levels. What was once a grassy park has now become a car park, showing how, whereas once day-trippers came by railway, today they travel in their cars. However, upon what was the photographer standing to have taken that early view? There is not, nor ever was, a convenient elevated position or structure upon which to stand, especially with a cumbersome camera and tripod.

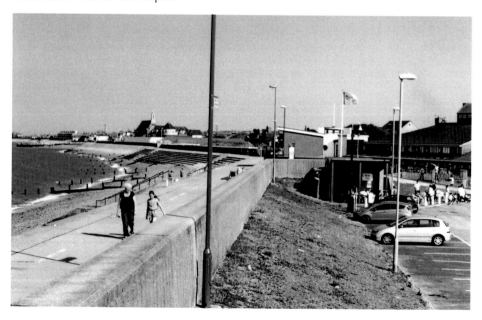

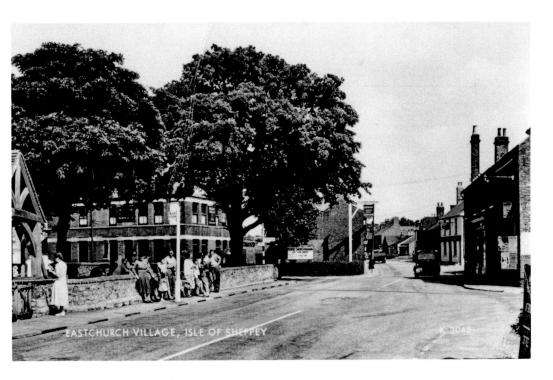

Eastchurch, Looking to the East

Very little difference can be seen between the top picture taken in the early 1960s and the lower one taken in 2010. The one obvious difference is in the number of cars parked on the roadside. The top picture clearly shows that people then were happy to wait for a bus to come along.

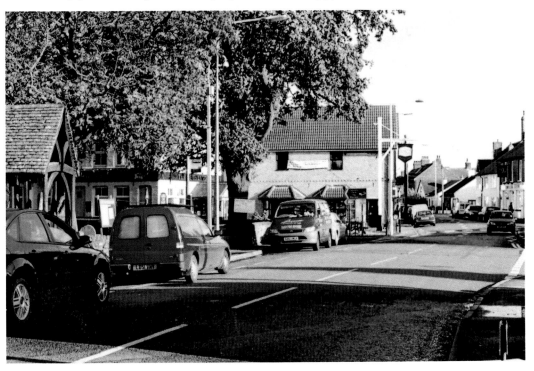

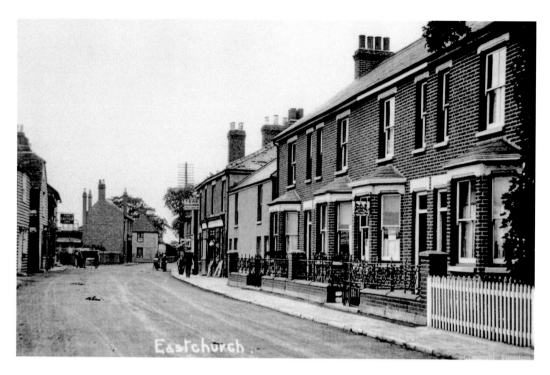

Looking Back Through the Village

An average Victorian/Edwardian terrace of houses, the like of which still forms the backbone of many towns and villages. Today there are a few variations where modern buildings have replaced older ones.

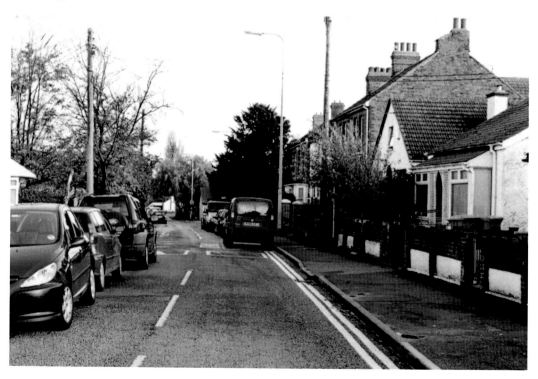

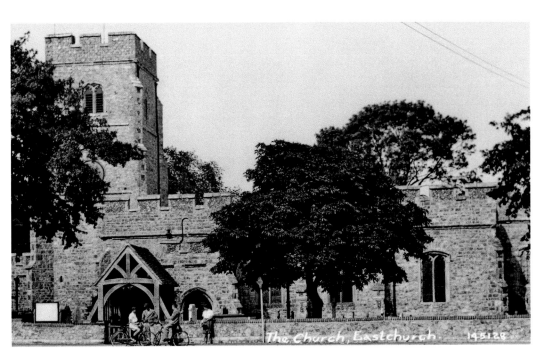

All Saints Church, Eastchurch

The village church, dedicated to All Saints, was built in 1432, replacing an earlier structure that was built in about 1279. It had become unsafe due to having been built on unstable ground. Such was its condition, it had to be completely demolished and the replacement church was built on a new site. The exact location of the earlier church and any adjoining settlement is no longer known. A worthy feature of note in the church is a stained glass window in the south side, dedicated to aviation pioneers Charles Rolls and Cecil Grace, who were killed in July and December 1910 respectively.

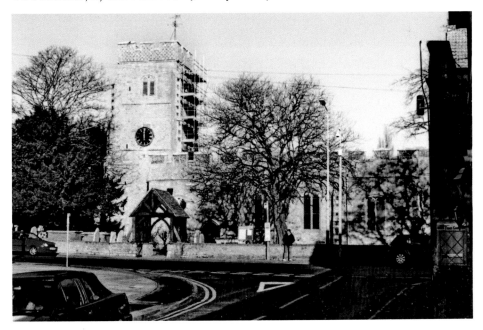

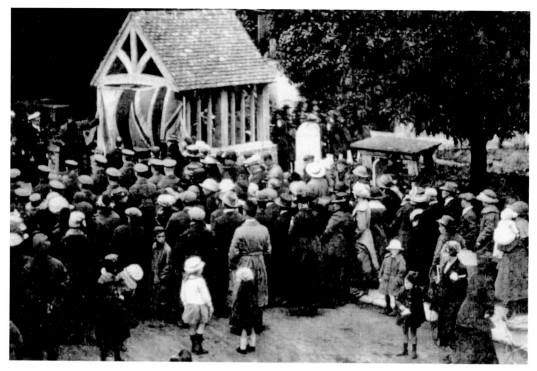

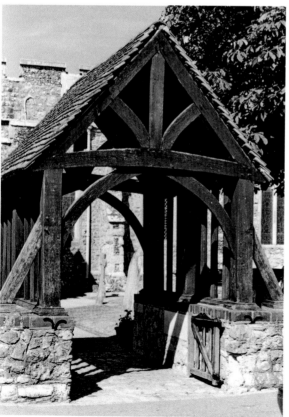

The Church Lych-Gate
One feature of interest in this church is the lych-gate, which was erected by the villagers as a memorial to the men who were killed in the First World War. It was unveiled in 1920.

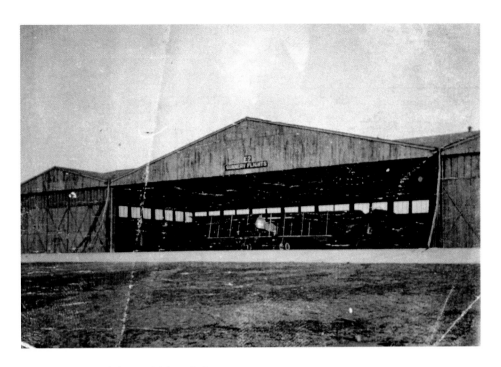

A Fitting Memorial to British Aviation

To mark Eastchurch as the birthplace of British aviation, this memorial was unveiled by Lord Tedder, Marshall of the Royal Air Force on 25 July 1955. Lord Tedder was at one time the CO of Eastchurch aerodrome. The second picture shows one of the early hangars, No. E2, used for gunnery flights with a Maurice Farman 75 HP air-cooled Renault V4 aircraft in the entrance. Some of these old hangars are still standing within the prisons complex, and I'm reliably informed that one still has bullet holes in its roof from an attack by German aircraft in Second World War.

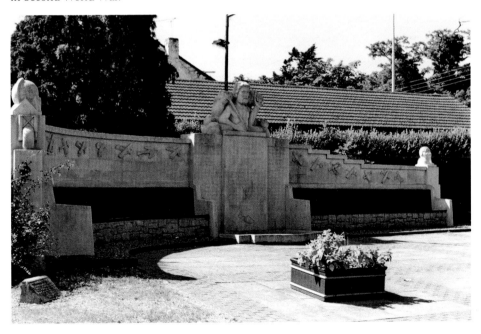

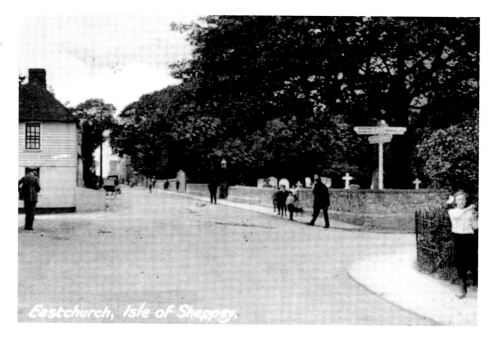

A Developing Village

With its airfield – later replaced by the prisons – Eastchurch quickly developed from a sleepy little village into a small town with amenities to serve its growing population, which was boosted by workers from Sheerness Dockyard. Agricultural land slowly gave way to fields that became holiday camps and, as nearby Leysdown expanded into a busy seaside resort, Eastchurch came to a grinding halt on summer weekends owing to heavy holiday traffic passing through. On the left of the early view taken in around 1920, a whitewashed weatherboard house can be seen, which was demolished to make way for the aviation memorial. The road to the right leads to the cliffs where Warden once stood.

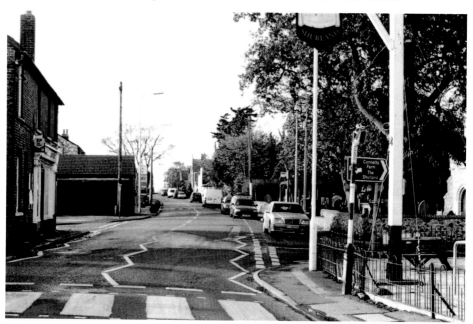

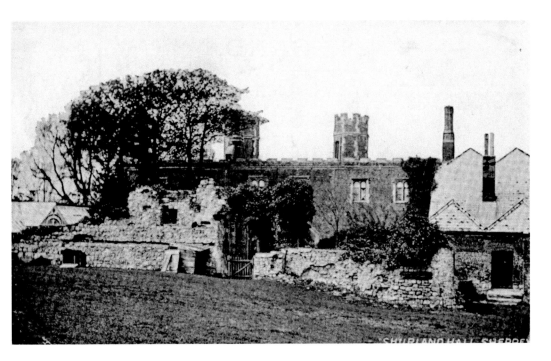

Shurland Hall

Eastchurch's 'big house' was Shurland Hall, an ancient building going back many centuries. It was named after its first owners, the De Shurland family, who were granted it, along with other land, by William the Conqueror. In its time it has hosted royalty – notably Henry VIII and his queen, Anne Boleyn when it was the home of William Cheney.

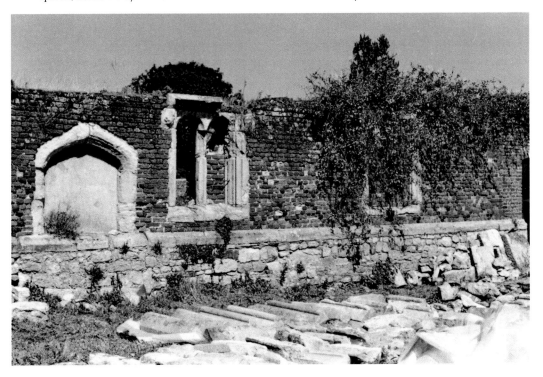

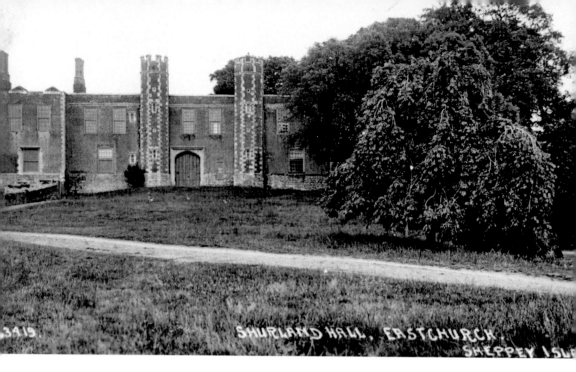

Shurland Hall

During the First World War, troops were billeted in the Great Hall, and it suffered considerable damage as a result. There has been no record of anyone living in the hall since then. In 2006, a grant of £300,000 was made by English Heritage to restore the hall's façade.

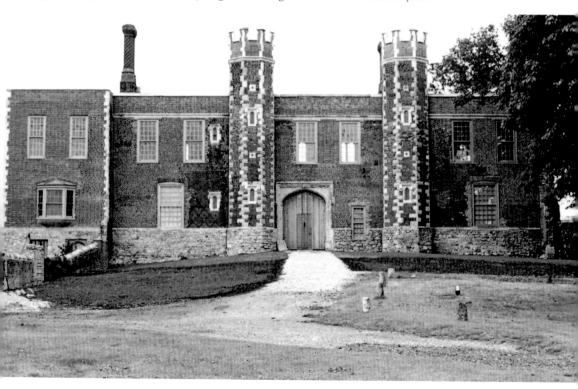

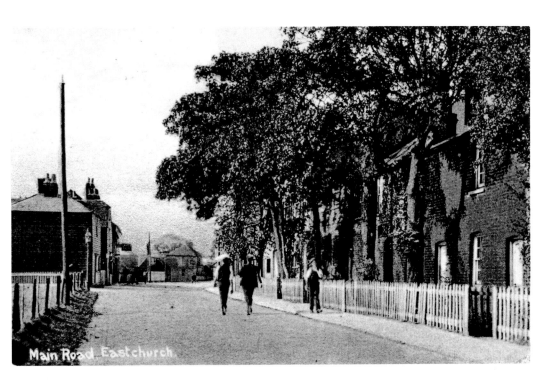

The Main Road

The main road through Eastchurch, looking in a westerly direction, *c.* 1907. Whilst the terrace of cottages on the right of the early view appears to have been demolished, those on the left can still be discerned beyond the trees. Walkers have given way to motor cars.

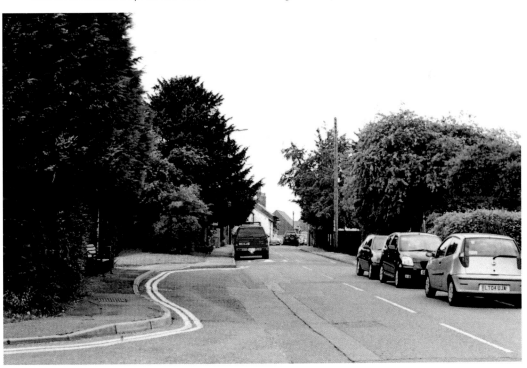

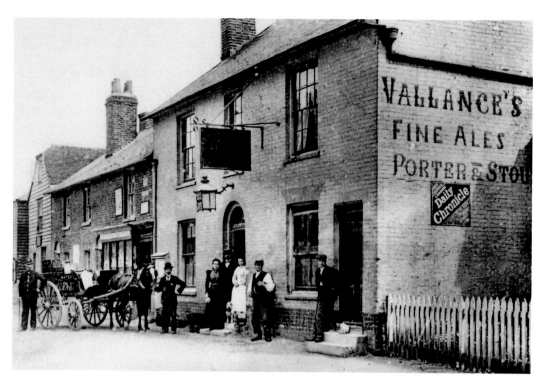

The Castle Pub

One of Eastchurch's local pubs is the Castle, a name it retains to this day. Structurally it remains untouched. Most noticeable is the absence of the centrally placed door in the early view.

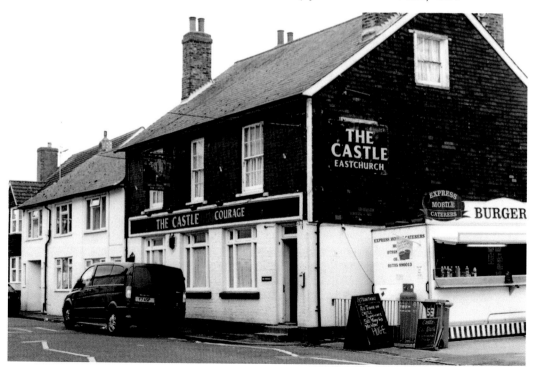

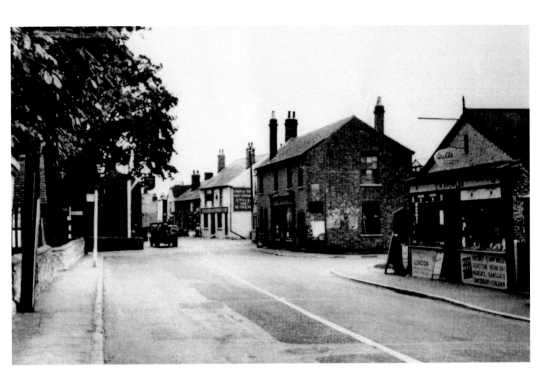

The Village Centre

The village centre outside the church has changed little over the centuries. The road to the right now leads to the island's three prisons, whereas once it would have taken villagers to the railway station and the marshes beyond.

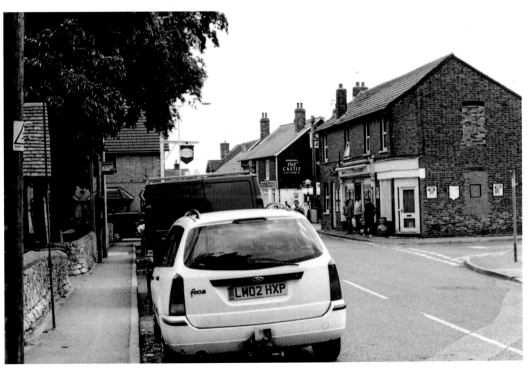

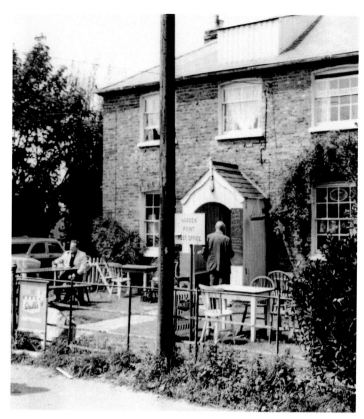

A Post Office Long Gone

In the 1950s, the hamlet of Warden had a post office – a modest concern set up in the front room of a private house. This was a common enough practice in the smaller villages and hamlets of that time. Anything larger was unsustainable. At some unknown point in time this building was demolished and the neighbouring property purchased the site for extending their garden.

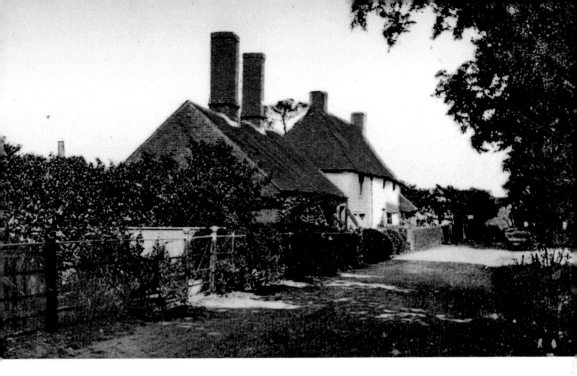

A Slowly Vanishing Road

The road running down the side of Eastchurch's parish church once led to Warden Point, a village that has for many years been gradually falling into the sea due to the erosion of the cliffs. The parish church, or what remains of it, now lies some distance offshore. How much longer will it be before this stretch of Warden Lane also succumbs to coastal erosion? Who can say for sure?

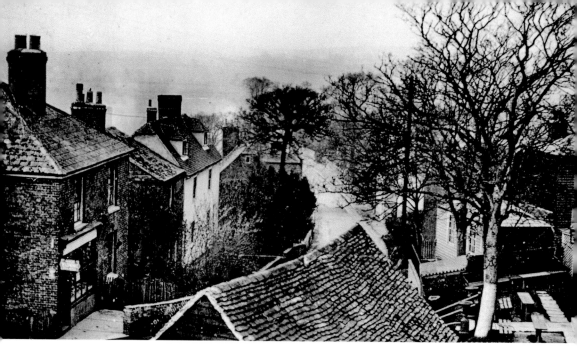

Minster High Street

From its lofty hilltop position, the abbey overlooks the main Halfway to Leysdown road passing below it. Since the earlier 1935 picture was taken, many of the cottages that once lined this hillside road have been demolished, as can be seen in this evocatively misty autumnal view taken in 2010, late in the afternoon, to convey the mysterious and ghostly qualities that surround the abbey.

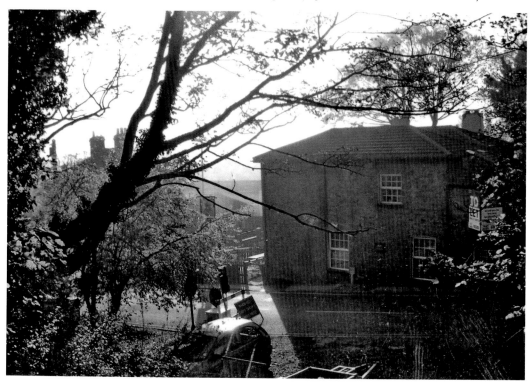

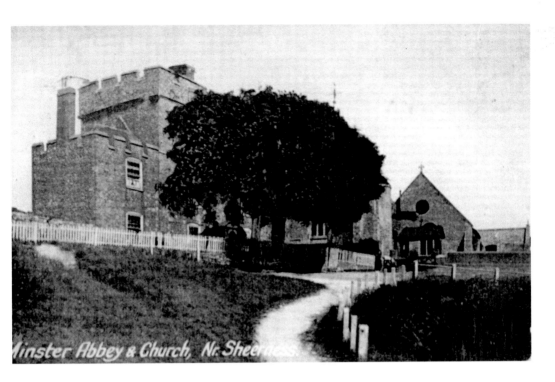

Minster Abbey & Church, Nr. Sheerness.

A Royal Abbey

Minster is by far the oldest inhabited part of the island and once had an abbey, which was founded by Sexburgha, the widow of Eorconberht, the Saxon king of Kent, in AD 675. The abbey is one of the oldest places of Christian worship in England and is referred to in the Domesday Book.

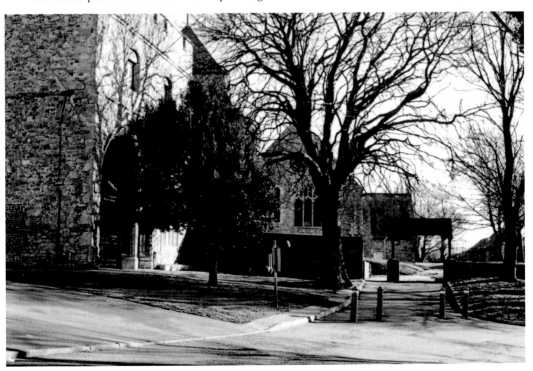

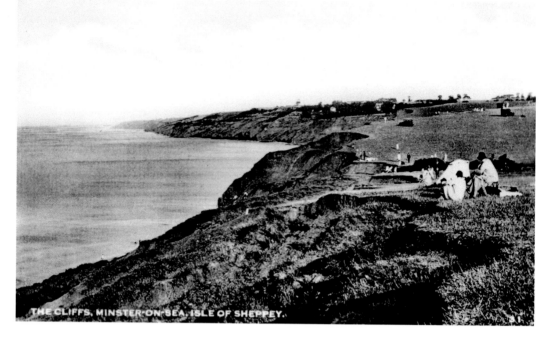

THE CLIFFS, MINSTER-ON-SEA, ISLE OF SHEPPEY.

Minster Cliffs

The northern coastline of Sheppey rises to almost 250ft at Minster where the cliffs have always been exposed to erosion. Many hundreds of acres of prime agricultural land, as well as decades of history, have been lost to the sea but this constant erosion has made it a fruitful area for fossil hunters and geologists. It is also a popular place for day-trippers to just sit and admire the expansive coastal views.

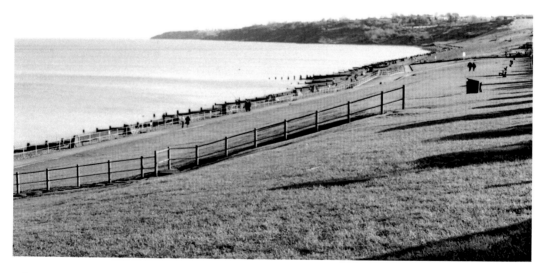

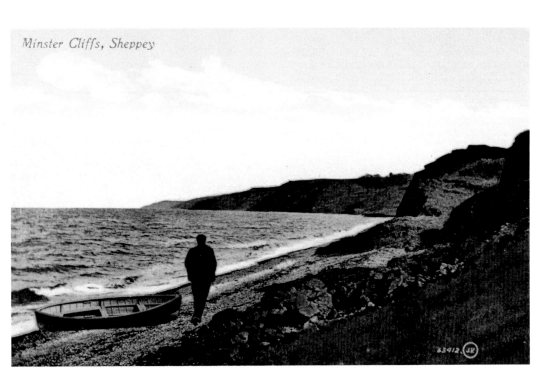

Minster Cliffs, Sheppey

Minster Beach

At the expense of the cliffs eroding, Minster has a beach that is gradually increasing in size as the cliffs fall away. It is here that fossils can often be found lying on the surface, awaiting the eagle-eyed hunter.

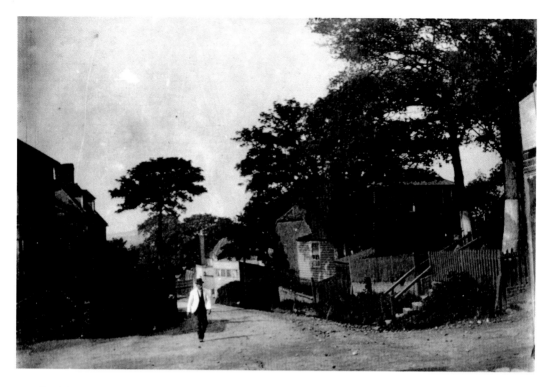

Overlooking the Main Road
Looking back, westerly, along the main road towards Halfway; very little seems to have changed in a century or more. The road to the right beside the pub ascends to the abbey.

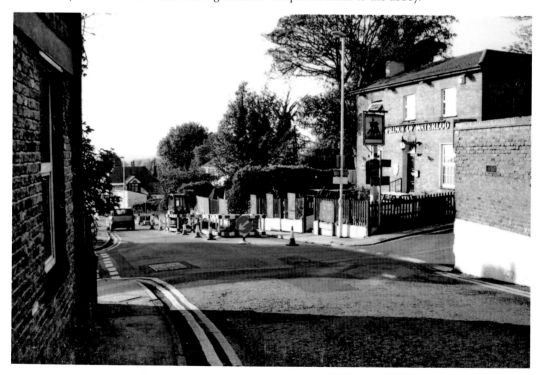

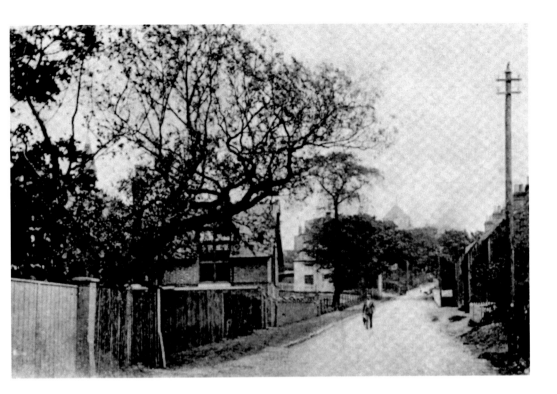

The Main Road Through Minster

The main road from Kingsferry Bridge to Leysdown passes through the village of Minster, famous for its ruined abbey. It has always been a busy road but here we see an almost total absence of traffic in 1904, compared with today. In both pictures the spire of the abbey church can just be seen peeping over the treetops.

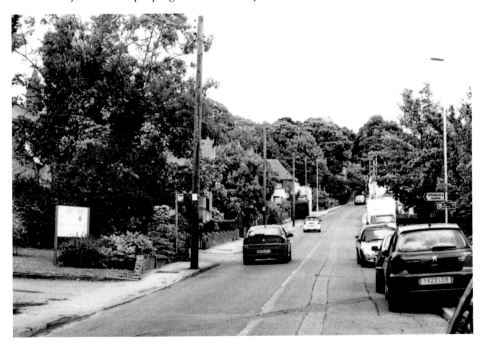

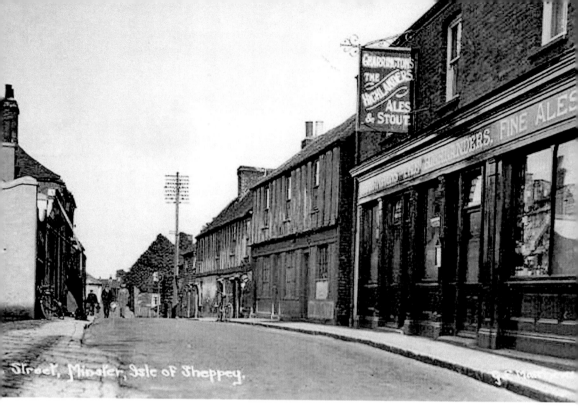

Street, Minster, Isle of Sheppey.

The Village Centre

The heart of Minster village lies in the shadow of the old abbey. The Highlander public house has retained its name over the years, despite a few modernising cosmetic changes to its frontage.

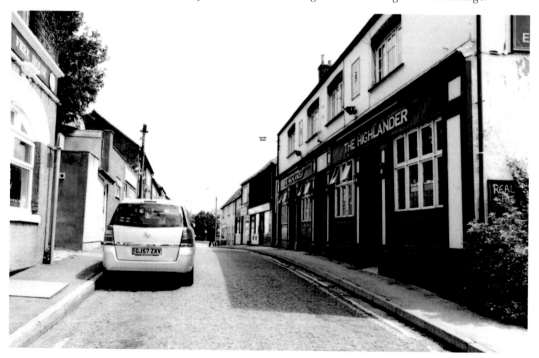

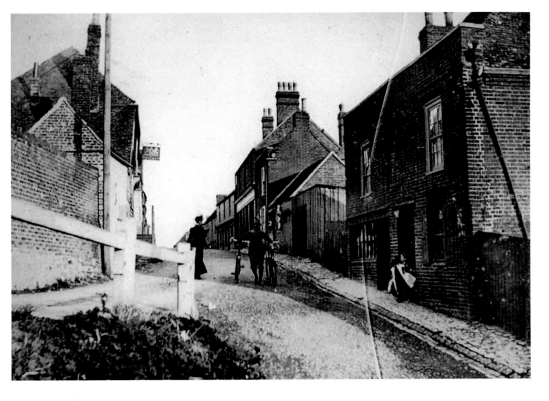

The Village Centre

Back down the hill from the Highlander is a former private house, which is now run as a newsagent's shop. I rather like the courteous gent pushing the lady's cycle up the hill as well as his own.

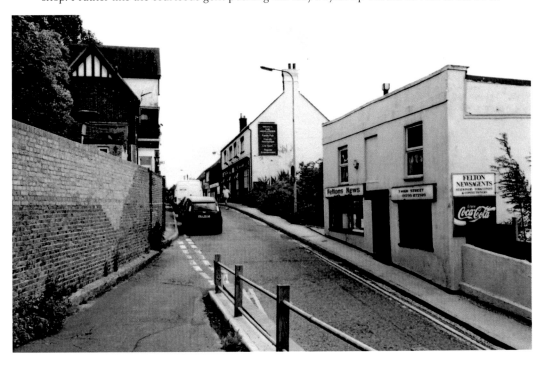

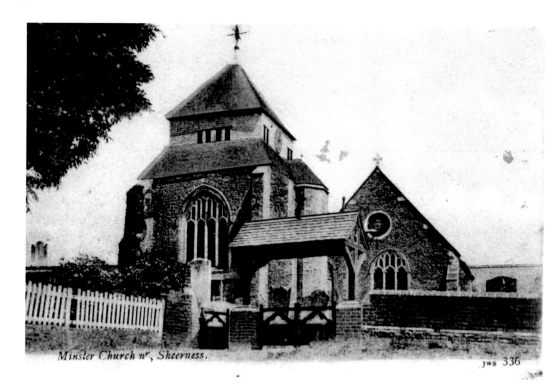

Minster Church nʳ, Sheerness.

JWS 336

Minster Abbey

The history of Minster Abbey dates back to AD 675 when it was founded by Queen Sexburgha, the widow of Eorconberht, the Saxon King of Kent. It has led a stormy life, having been attacked by the Vikings in AD 835 and eventually destroyed during the Reformation in the reign of Henry VIII. Today, only the gatehouse and the church remain, but the once open vista, seen here in 1906, is now obliterated by trees and other vegetation.

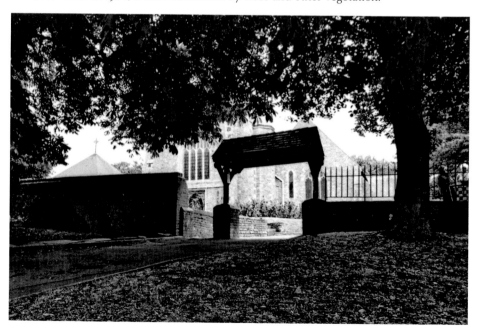

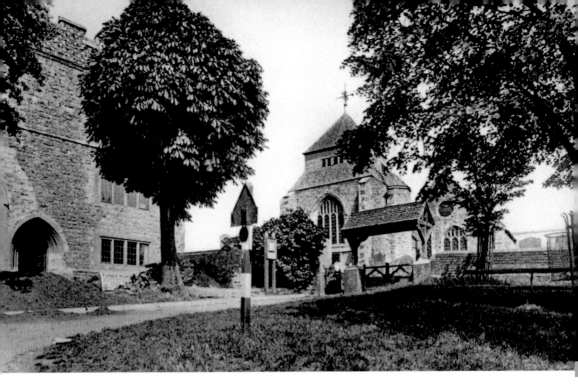

The Gatehouse
Once admitting pilgrims and other visitors into the abbey complex, today the Gatehouse stands forlornly alone. It is currently used as a museum, displaying many aspects of Sheppey's past. From its top, visitors get expansive views of the Thames estuary and its shipping.

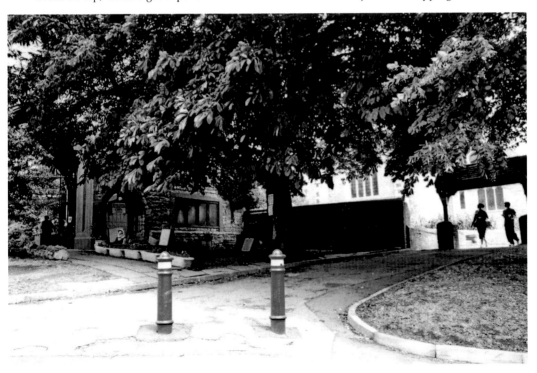

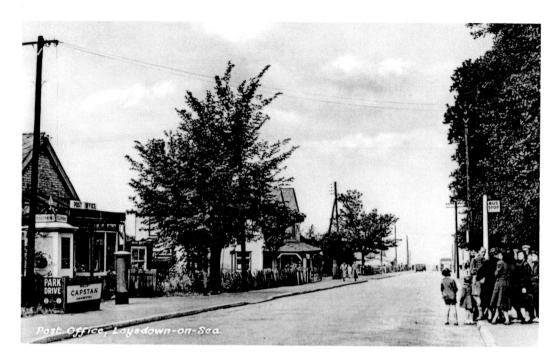

Post Office, Leysdown-on-Sea

Leysdown, a Holiday Resort for All

At the far eastern end of the island is Leysdown, which as a village dates back to at least the time of the Domesday Book when it was known as *Legesdun*. Its long, flat sandy beach makes it ideal for family holidays, and as the number of post-war holiday camps and caravan parks started to grow, so too did the many amusement arcades and fast food outlets that sprang up along the approach road to the beach. How very different these two views are; the first taken immediately after the war in 1949, when the village was still very much unspoilt, compared with this later view of the same stretch of road today.

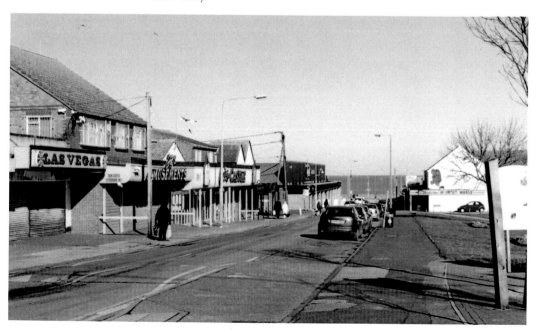

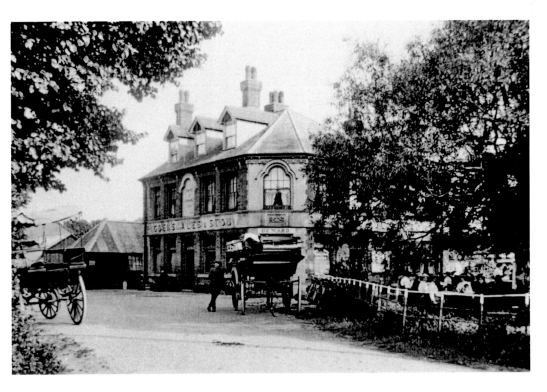

The Rose and Crown Pub

Leysdown's main pub, the Rose and Crown is one of the few substantially built buildings in the village.

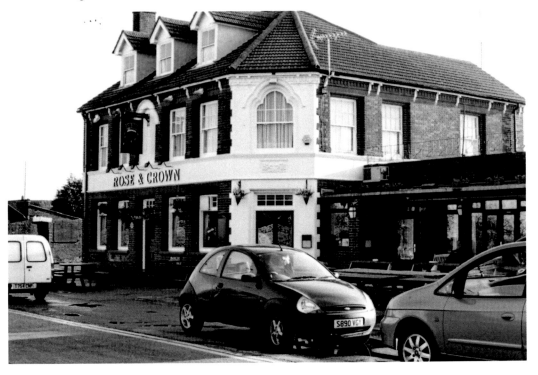

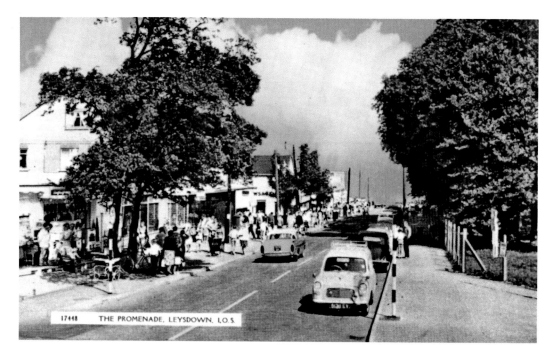

17418 THE PROMENADE, LEYSDOWN, I.O.S.

Proof if Proof is Needed

Within twenty years of the end of the war, Leysdown had established itself as a holiday resort that rivalled the nearby town of Sheerness. It was particularly popular with London's East Enders, probably because most of its holiday accommodation consisted of inexpensive caravans, chalets and tented sites; there were no irate landladies to appease. The top picture was taken in 1964 and it is evocative of the times that part of the message reads, 'There are so many Mods here that I can't take them all in. You'd like it here!' Ah, the swinging Sixties indeed.

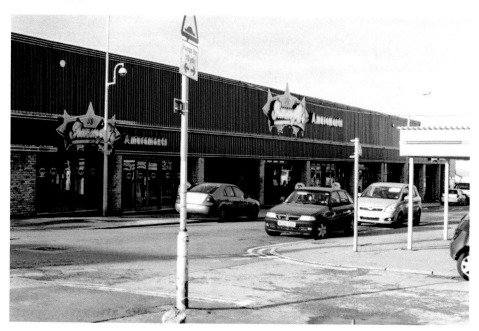

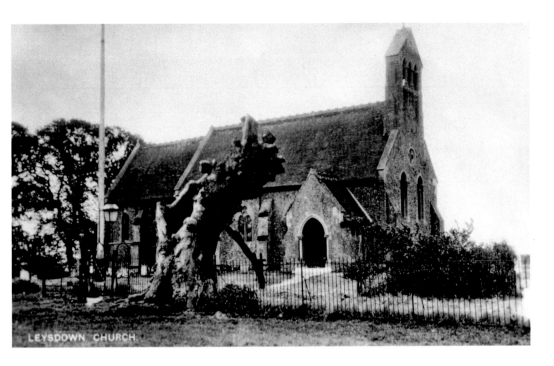

LEYSDOWN CHURCH.

St Clement's Church, Leysdown

This church replaced a much earlier one whose date of construction is unknown. By 1734 it was in such a state of dereliction that there was no alternative but to demolish it and build another in 1874 –seen in the top picture – to a design by R. Wheeler. Unfortunately, that too has gone the way of the first and it was demolished in 1989. Today only tantalising glimpses are left, such as the lych-gate and sections of the churchyard.

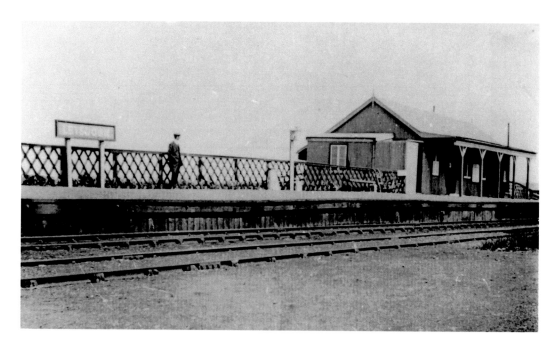

The End of the Line

The Isle of Sheppey once had its own railway line, the Sheppey Light Railway, which crossed the island from Queenborough to Leysdown. Opening in 1901, it closed down in December 1950 in the face of increased competition from charabancs and buses. Here we see Leysdown station during its heyday, compared with the site today. The gap between the trees is the old railway line bed and this can be seen at various places between here and Eastchurch where the line emerged from the marsh.

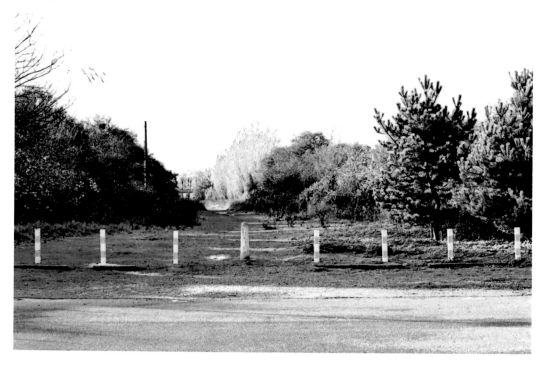

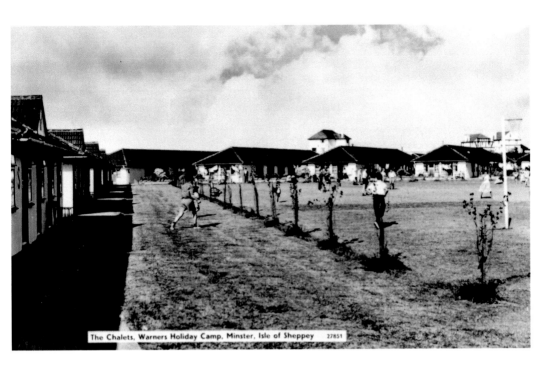

The Chalets, Warners Holiday Camp, Minster, Isle of Sheppey 27851

Hi-de-hi Campers!

Holiday camps of different sorts are synonymous with Leysdown. Beginning in the post-war years of the 1950s, they rose to the height of their popularity in the 1960s. One such multi-national company to have a holiday camp here was Warner's and here we see a typical layout of chalets, compared with the much later, more upmarket layout of Priory Hill Holiday Park in Wing Road, Leysdown.

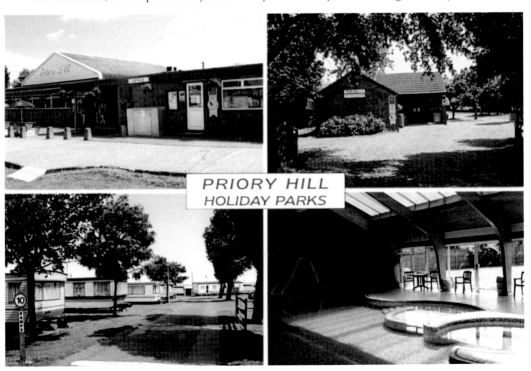

PRIORY HILL
HOLIDAY PARKS

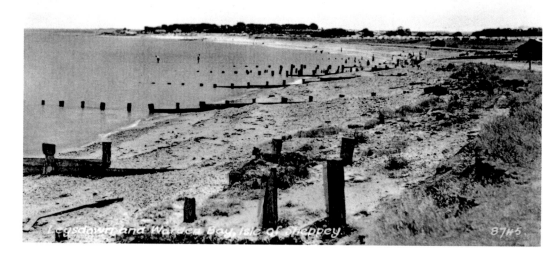

Leysdown Beach

Looking remarkably unchanged after a century and more, it is hard to date pictures of the beach at Leysdown. It has never been 'developed', as have the beaches at many other resorts. It always has, and will probably long remain, as a sandy foreshore with no distractions. Nevertheless, it is popular with sun worshippers.

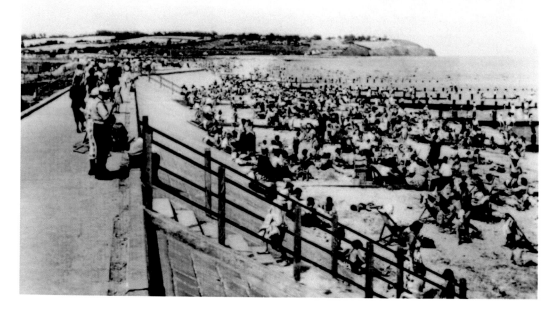

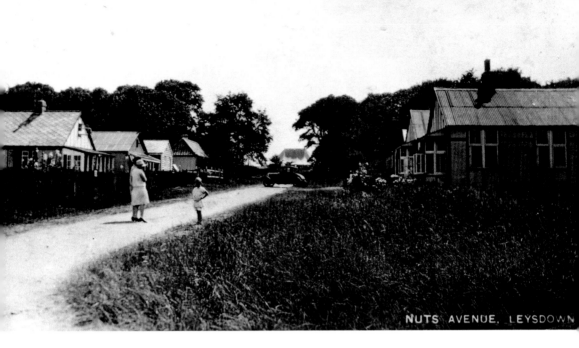

NUTS AVENUE, LEYSDOWN

Early Life at Leysdown

One of the earliest roads of holiday homes in Leysdown is Nutts Avenue. Today, many of those early bungalows have long gone, replaced by more luxurious mobile homes. It appears that the tree overhanging the road in the distance is still there.

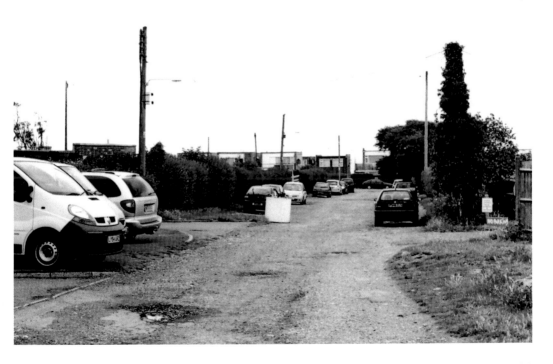

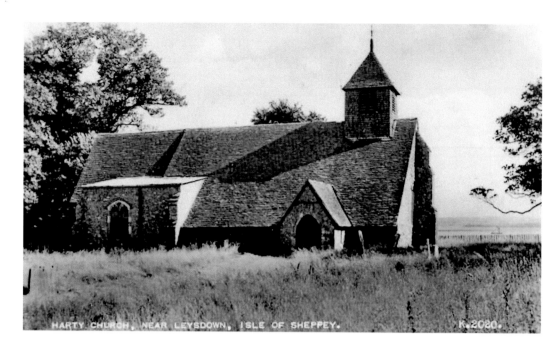

HARTY CHURCH, NEAR LEYSDOWN, ISLE OF SHEPPEY. K.2080.

Harty

Harty was once one of three separate islands that together constituted the Isle of Sheppey. Situated on its far south-eastern tip, it was a self-contained hamlet that overlooked the eastern entrance to the Swale. It was also one of the three ferry crossing points, taking its passengers to and from Faversham. Today, only the Ferry inn and its eleventh-century church – dedicated to St Thomas the Apostle – remain, and despite there not being a local population, services are still occasionally held there. It is often referred to as 'the remotest church in Kent'. Part of its appeal is in not having an electricity supply; the church is lit by candles and oil lamps.

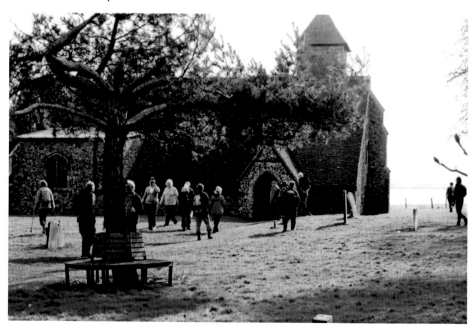

Acknowledgements

I would like to record my sincerest thanks and gratitude to the following people for their help and assistance in compiling this book. Without their help it would not have been possible to present a full and accurate picture of the changes that have taken place over the years on the Isle of Sheppey. Thanks go to Mrs Pat Clancy, Barry Kinnersley, Mick Clancy, Trevor Edwards, Sheerness Heritage Centre & Paul Dummott, Mrs Janet Halligan and Terry Walsh. I would particularly like to thank Barry Kinnersley for photographing many of the modern-day views, something I was not able to do myself due to pressure of other work. I know Barry has an eye for the detail and angles required so I felt perfectly safe in leaving this in his more than capable hands. The results fully justify my trust in him. It was not a particularly easy task to undertake as many of the scenes have changed so much in the past decades and Barry is not a local lad by birth, but he diligently tracked down each location. Furthermore, what perplexed Barry, as it did me too, was the fact that despite standing in the exact same spot that those early photographers stood in, there was a noticeable difference in the pictures they and we captured. It seems that the cameras of old were not quite the same as those we use today. It's all to do with lenses, focal planes, the type of camera, and other technicalities. I would also like to make special mention of Colin Harvey who gave me considerable help in allowing me to use many images from his extensive private collection of photographs, each of which he has digitally enhanced and cleaned up to give a picture of optimum quality and standard.

Acknowledgement should also be made of the work of the early postcard photographers, many of whose names have long been forgotten but without whom we would not have such splendid early views of the island. Although many of the scenes they captured have not changed much in a century or more, close inspection reveals the subtle changes that have taken place. Their work deserves special mention because

through it they ensured a record for future evaluation. The fashion for sending picture postcards to friends and family a century ago or more has left us with a rich legacy of a window-peering into everyday life as it was then. Every part of a postcard from the picture to the stamp, the postmark, the message it contains and the address is a reminder of a time gone by and a valuable record of our social history.

Every effort has been made to authenticate the information received from these people and other sources but sometimes time can play tricks on the memory, so if any part of my text is inaccurate I sincerely apologise and will endeavour to correct it in any future editions of this book. Every reasonable effort has been made to contact the copyright holders of the photographs and illustrations used herein but should there be any errors or omissions or people whom I could not contact, I will be pleased to insert the appropriate acknowledgement in any future edition of this book.

John Clancy BA (Hons)